HENRI CARTIER-BRESSON WALKER EVANS

HENRI CARTIER-BRESSON
WALKER EVANS
PHOTOGRAPHING
AMERICA 1929–1947

CONTENTS

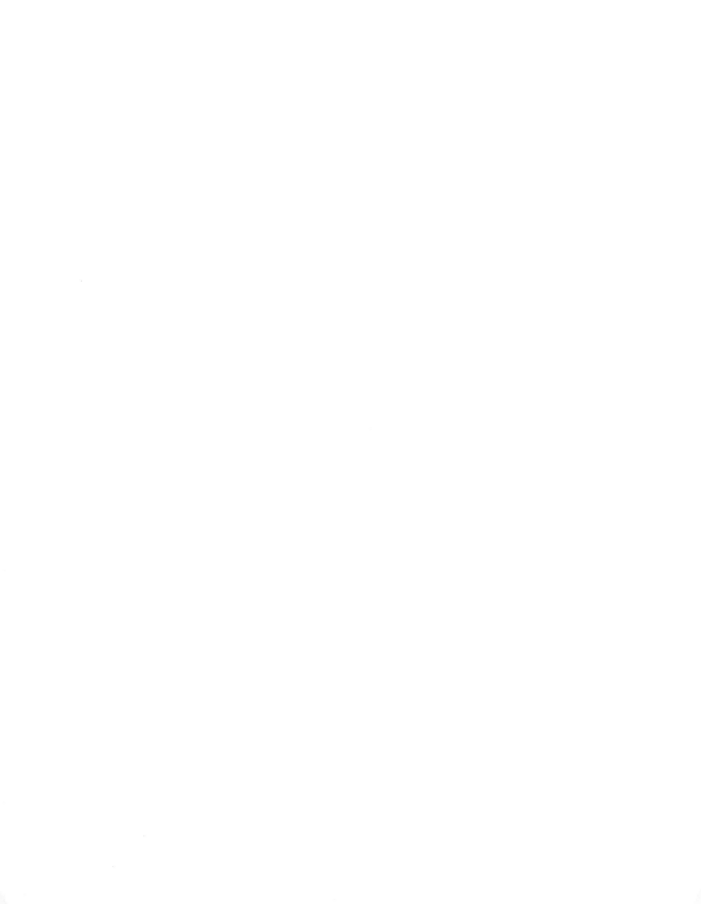

If it had not been for the
chalenge of the work
of Walker Evans I don't
think I would have
remained a fotographer

Henri Cartier-Bresson

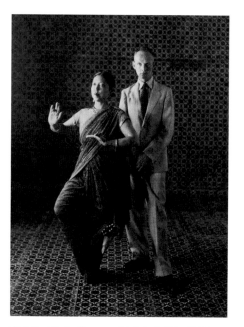

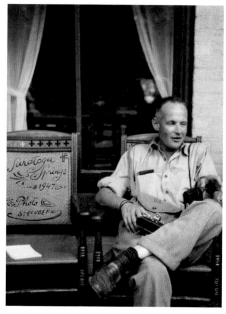

Fig. 1 Henri Cartier-Bresson and his first wife Ratna Mohini,
New York, 1946 (Irving Penn, courtesy Conde Nast, Inc.)

Fig. 2 Henri Cartier-Bresson, Saratoga Springs, 1947
(Saul Steinberg)

INTRODUCTION Agnès Sire

On 15 May 1946, Henri Cartier-Bresson arrived in New York harbour on the ocean liner *Oregon* in the company of his first wife, Ratna. He had with him all the small work prints intended for the preparation of his exhibition at the Museum of Modern Art, which was supposed to take place imminently. In fact, Beaumont and Nancy Newhall, who thought he had died during the war, were planning to give him a 'posthumous' exhibition when they learned from David 'Chim' Seymour that Cartier had escaped and more or less gone into hiding in France with false papers.[1]

A few days after their arrival, the Cartier-Bressons (fig.1) paid a visit to Nancy and Beaumont Newhall. As Beaumont Newhall noted on 24 May 1946, Henri Cartier-Bresson and his Javanese wife arrived at one. We liked them both at once. Cartier looked like a scrubbed college boy, in tweeds, with a crew haircut. His wife, in a sari, dark-skinned, with oriental eyes and a caste mark on the forehead, proved to be very easy to talk with, speaking English almost as fluently and well as Cartier.[2] Beaumont Newhall (fig.6) had left MoMA but he nonetheless offered Cartier his advice for the conception of the exhibit, which he regretted not being able to install with him.

In the end, the exhibition, planned for autumn 1946, did not open until in February 1947. Cartier was in a delicate situation: he had to earn a living and obviously knew how to respond to photography commissions, but before the war, he had decided to become a filmmaker.[3] After three years of captivity, the experience of the war and the making of his documentary film *Le Retour* (The Return, 1945), the man had clearly changed, matured, but he was still undecided about his professional future.[4] (fig.2) The first steps of the Magnum co-operative, his conversations with Robert Capa and his insatiable curiosity about the world ultimately led him to opt for photography.[5] His partner on *Le Retour*, Lieutenant Banks, who tried to help him before his arrival in New York, reported to Nancy Newhall, 'Henri Cartier-Bresson has usual resistance and dislike of assignments. He would like to do something he really feels on America while here.'[6]

1 We will use the shortened form 'Cartier', as he was called at the time. Interned in the Ludwigsburg prisoner of war camp stalag VA KG845, he escaped on 10 February 1943. / 2 Beaumont Newhall, Journal, The Getty Research Library, Los Angeles, California. / 3 After studying filmmaking with Paul Strand and showing his photographs to Jean Renoir, Cartier became Renoir's assistant on three films and subsequently made five documentaries of his own. / 4 *Le Retour* was a film about the return of the prisoners, co-directed with Lieutenant Richard Banks and produced by the United States Office of War Information. / 5 'Watch out for labels. They're reassuring but somebody's going to stick one on you that you'll never get rid of – "the little surrealist photographer". . . . Take instead the label of "photojournalist" and keep the other thing for yourself, in your heart of hearts.' Robert Capa, April 1947, quoted by Russell Miller, *Magnum, Fifty Years at the Front Line of History* (London: Secker and Warburg, 1997), p. 60. / 6 Letter to Nancy Newhall, 24 January 1946.

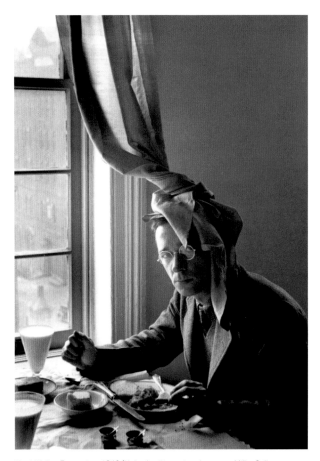

Fig. 3 Walker Evans, circa 1940 (Helen Levitt, courtesy Laurence Miller Gallery, New York)

It was clearly his admiration for the accomplishment of Walker Evans's work which made Cartier become aware of what could be done with photography in a more professional way, without losing his freedom and his ethic. As he wrote to Peter Galassi in March 2001, 'If it had not been for the challenge of the work of Walker Evans, I don't think I would have remained a fotographer.'[7]

WALKER EVANS

Five years Cartier-Bresson's senior, Evans (fig.3) had already published several books, including his master-piece, *American Photographs* (1938).[8] In 1926 he had spent eight months in France and travelled elsewhere in Europe; passionately interested in painting and literature, he also tried his hand at translation.[9] Compared to all of Cartier-Bresson's travels in Africa, Europe, the United States, Cuba and Mexico over a period of five or six years, Evans ultimately travelled very little. On his return to New York, he struck up a friendship with Lincoln Kirstein and photographed the city.[10] Later on, in February 1934, he wrote to his friend Ernestine Evans, 'What do I want to do? . . . I know now is the time for picture books. An American city is the best. . . . I am not sure a book of photos should be identified locally.'[11] He was also one of the artists at the Julien Levy Gallery, where he exhibited for the first time in 1932 and again in 1935 for 'Documentary and Anti-graphic photographs' along with Manuel Alvarez Bravo and Cartier.[12] (fig.4) He was the incarnation of a revolution in the history of American photography: 'I wasn't drawn to the world of photography. In fact I was against the style of the time, against salon photography. . . I was against the grain.'[13]

His 1938 MoMA exhibition, 'Walker Evans, American Photographs', marked a critical turning point in the history of the author's relationship to the museum, to his work and to the book. As was the case later on for Cartier, it was Lincoln Kirstein who introduced him and wrote the postface to the catalogue: 'The photographic eye of Walker Evans represents much that is best in photography's past and in

7 Letter to Peter Galassi, chief curator of the Department of Photography at The Museum of Modern Art, in March 2001 to thank him for the catalogue *Walker Evans and Others*. Fondation HCB archives, Paris. / 8 *Walker Evans, American Photographs*. With an essay by Lincoln Kirstein (New York: The Museum of Modern Art, 1938). He had previously published a few images in *The Bridge* by his friend Hart Crane in 1930, and *The Crime of Cuba* with Carlton Beals in 1933. / 9 Evans took French classes at the Sorbonne, had the ambition of becoming a writer, read a great deal of poetry and translated, among others, Baudelaire's prose poem 'La Chambre double' (The Double Room). / 10 Lincoln Kirstein (1907–1996), an eminent figure in American cultural life, was the founder and president of the New York City Ballet and founder-editor of the literary magazine *Hound & Horn*. Involved in the creation of the Museum of Modern Art in New York, he was the author of many essays. / 11 Cited by Judith Keller, *Walker Evans, The Getty Museum Collection*, (Malibu, Ca.: J. Paul Getty Museum, 1995) p. 131. Ernestine Evans was then a literary agent. / 12 The Fondation Henri Cartier-Bresson reconstituted this exhibit in 2004. See *Manuel Alvarez Bravo Henri Cartier-Bresson Walker Evans: Documentary and Anti-graphic Photographs*. Essays by Agnès Sire, Daniel Girardin, Ian Jeffrey, Michel Tournier, Peter Galassi and Jeff Rosenheim (Göttingen: Steidl, 2004). / 13 Interview with Paul Cummings, Archives of American Art, Oral History Program, 1971.

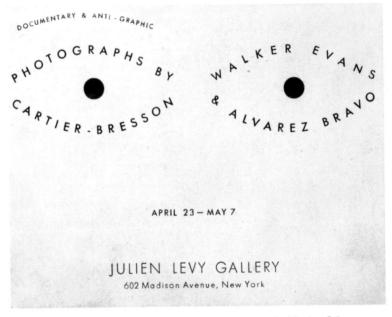

Fig. 4 Invitation card to the exhibition *Documentary and Antigraphic photographs*, Julien Levy Gallery, New York, 1935

its American present. His eye can be called, with that of his young French colleague, Cartier-Bresson, anti-graphic, or at least anti-art – photographic.'[14] Evans laid out the book with great precision, structuring it in an exemplary way which was in fact different from the exhibition (fig.14).

In his essay 'Walker Evans, *American Photographs* et la question du sujet', Jean-François Chevrier provides an excellent analysis of the way the book functions and its importance in this respect: 'Going back to the example of Atget, transposed to the American situation, Evans created a new relationship between the Surrealists' "poetic document" and the documentary investigation. . . . He was breaking with the rhetorical effects of photojournalism.'[15] Indeed, there were no hesitations with Evans, but rather, a subtle sensibility driven by a profound desire to show, to preserve a trace. In an unpublished author's note for the original edition of *American Photographs*, Evans explains: The aim of the following picture selection is to sketch an important, correct, but commonly corrupted use of the camera... There are moments and moments in history, and we do not need military battles to provide the images of conflicts. . . . But we do need more than the illustrations in the morning papers of our period.[16]

In another unpublished author's note intended to accompany the 1961 reissue of the book, he adds, 'Evans was, and is, interested in what any present time will look like as the past'.[17] But if this seems like a clear definition of the photographic act in the absolute, it is not at all what counts most for Cartier when he speaks of photography, be it 'the imagination, from life', 'the eye alone, in its surprise, which can decide' or the moment: 'Time flies by and only our death manages to catch up with it. The photograph is the blade which seizes the dazzling instant from eternity.'[18]

CARTIER-BRESSON'S TRIP TO THE U.S.

'Who's Cartier-Bresson?' poet John Malcolm Brinnin asked his friend Truman Capote in the summer of 1946: 'This photographer Carmel Snow's imported from France. Very eminent, the Museum of Modern

14 *Walker Evans: American Photographs*, Fiftieth Anniversary Edition (New York: The Museum of Modern Art, 1988), p. 192. / 15 Jean-François Chevrier, 'Le parti-pris du document', *Communications* no. 71 (Paris: Editions du Seuil, 2001), pp. 63, 64. / 16 Jerry Thompson and John T. Hill (eds), *Walker Evans at Work* (New York: Harper and Row, 1982), p. 151. / 17 Ibid. / 18 Written for *I Tempi di Roma* (Paris: Adam Biro, 2000).

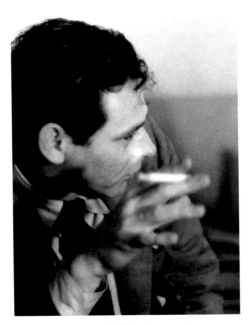

Fig. 5 James Agee, circa 1940 (Walker Evans, courtesy
Galerie Baudoin Lebon, Paris)

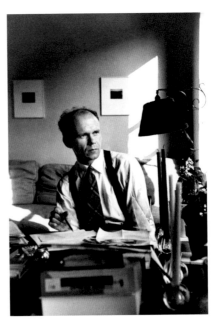

Fig. 6 Beaumont Newhall, New York, 1947
(Henri Cartier-Bresson)

Fig. 7 John Malcolm Brinnin, Berkeley, 1947
(Henri Cartier-Bresson)

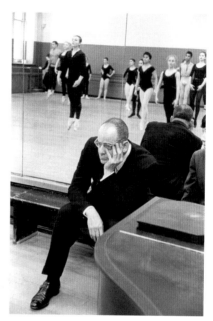

Fig. 8 Lincoln Kirstein, New York, 1959
(Henri Cartier-Bresson)

Fig. 9 Truman Capote, New Orleans, 1947 (Henri Cartier-Bresson)

Art's giving him a one-man show. *Harper's Bazaar* wants a piece on New Orleans. Me to write it, Cartier-Bresson to illustrate it.'[19] Capote and Cartier were to spend two weeks travelling in the south of the United States, some ten years after Evans's photos taken with James Agee (fig. 5) for *Fortune Magazine*, on the daily life of three families in Alabama.[20] By that time April, 1946, Evans had been working for a year as a staff photographer at *Fortune*, where he was to remain for another twenty years, while continuing to photograph and collect articles, photos and postcards (which have been brought together by Jeff L. Rosenheim in *Unclassified*).[21]

Capote (fig. 9), according to Brinnin, came back with 'swollen ankles and fallen arches'.[22] He was later to write in his book *Dogs Bark: Public People and Private Places*: 'I remember once watching Bresson at work on a street in New Orleans – dancing along the pavement like an agitated dragonfly, three Leicas swinging from straps around his neck, a fourth one hugged to his eye: click-click-click (the camera seems a part of his own body), clicking away with a joyous intensity, a religious absorption. Nervous and merry and dedicated, Bresson is an artistic "loner", a bit of a fanatic.'[23] Cartier clearly liked to photograph alone – it was essential to his way of seeing – in order to be intensely concentrated, as Herrigel had explained in *Zen in the Art of Archery*, in order to aim accurately, but with no purpose whatsoever.[24] In his essay in the 1947 MoMA catalogue, Lincoln Kirstein (fig. 8) writes, 'The decisive part of Cartier-Bresson's particular process takes place not in the mechanism in his hand but in the vision in his head; in that right eye which (he says) looks out onto the exterior world, and that left eye which looks inside to his personal world.'[25] It was probably quite difficult to have the necessary agility for this sort of gymnastics of the eye, combined with the attention paid to a travelling companion, especially if we imagine Cartier's 'dance' as described by Brinnin at the outset of their trip: 'His eye is polyhedral, like a fly's. Focusing on one thing, he quivers in the imminence of ten others. . . . When there's nothing in view, he's mute, unapproachable, hummingbird tense.'[26]

In 'Random Notes and Suggestions' from around 1966, Walker Evans gave his students at Yale this advice: 'Work alone if you can. . . . Companions you may be with, unless perfectly patient and slavish to your

19 Truman Capote, quoted by John Brinnin in *Sextet: T. S. Eliot & Truman Capote & Others* (New York: Delacorte Press/Seymour Lawrence, 1981), p. 100. Carmel Snow (1887–1961) was the influential editor-in-chief of *Harper's Bazaar*. / **20** *Fortune* refused to publish the reportage; it was to appear in book form in 1941 as *Let Us Now Praise Famous Men* (Boston: Houghton Mifflin). / **21** *Unclassified, A Walker Evans Anthology* (Zurich and New York: Scalo/The Metropolitan Museum of Art, 2000), in collaboration with Douglas Eklund. / **22** *Sextet*, p. 100. / **23** *Dogs Bark: Public People and Private Places* (New York: Random House, 1973), p. 391. / **24** Eugen Herrigel, *Zen in the Art of Archery* (1948). Translated from the German by R. F. C. Hull. (New York: Pantheon Books, 1953). Georges Braque gave Cartier this book in 1958 and he considered it a reference. / **25** *The Photographs of Henri Cartier-Bresson*. Texts by Lincoln Kirstein and Beaumont Newhall (New York: The Museum of Modern Art, 1947), p. 8. / **26** *Sextet*, p. 110.

Fig. 10 William Faulkner, Mississippi, 1947 (Henri Cartier-Bresson)

genius, are bored stiff with what you are doing. This will make itself felt and ruin your concentrated, sustained purpose.'[27] His collaboration with James Agee had worked well. In Evans's eyes, Belinda Rathbone tells us, Agee was 'one of the few people . . . who understood the real value of his photography.'[28] The two friends had remained totally independent: 'They resisted the idea that one medium might serve to illustrate the other, or that either might dominate.'[29] In the end, after much hesitating and a great deal more time than *Fortune* had given them for the assignment, they concentrated their efforts on a few specific places – three families of tenant farmers.

Cartier's relations with Carmel Snow and *Harper's Bazaar* were excellent and he greatly appreciated the elegance of Alexey Brodovitch's layouts. Nonetheless, he was tired of sporadic commissions and started thinking about a long journey 'from one ocean to the other' in order to do a book with two voices, photographs and texts. 'I take photos because I don't know how to write,' he told a journalist who wanted to know the reason behind this choice. In fact, Cartier had a passion for literature: he escaped from the POW camp with an anthology of French poetry in his pocket – his Leica had been buried in the Vosges before the war – and his tastes ranged from Mallarmé to Saint-Simon, Stendhal with his 'little details', and Joyce. The notes he drafted to accompany his photos when they were published were often written with a great deal of talent, as well as humour – something which is not always visible in the images.

With the preparations for his MoMA exhibition advancing quickly, Cartier suggested after a few meetings with John Malcolm Brinnin (fig. 7), a young poet much in vogue with the critics at the time and introduced to him by Truman Capote, that they set off together after the opening. This long trip by car, with Brinnin behind the wheel, choosing the itinerary while Cartier decided when to stop, got underway at the beginning of April 1947. The idea was to make a book together, to be designed by Brodovitch and published by Pantheon Books. Cartier had an agreement with Snow that he would photograph the artistic figures they met along the route for *Harper's Bazaar*, in exchange for the money they needed to get by. Some of Cartier's future subjects were people he already knew, such as Dorothea Tanning, Max Ernst,

27 *Walker Evans at Work*, p. 222. / 28 Belinda Rathbone, *Walker Evans, A Biography* (Boston and New York: Houghton Mifflin Company, 1995), p. 120. / 29 Ibid., p. 129.

La photographie, ainsi que je la comprends , est simplement
un autre moyen de prendre des notes . Comme toutes notes, les notes
photographiques sont forcément incomplètes, car il se peut qu'elles n'ex-
priment pas le sujet sous toutes ses faces , mais chaque photographie
doit toucher l'essentiel du sujet car le déclic rend cette photographie
définitive . Ce livre donc, n'est pas plus une étude de sociologie
ou d'ethnologie qu'il n'est un livre de voyage dont le but serait de pré-
senter un panorama complet des États-Unis et du peuple américain mais
bien plutôt une histoire visuelle dans la-quelle j'ai essayé d'offrir
quelques uns des aspects riches et variés de la vie américaine que j'ai
observés .

Si dans mes photographies il m'arrive rarement de montrer
les réalisations humaines - telles que les gratte-ciel, telles que les
ponts - ce n'est pas parceque je ne goûte pas leur beauté et leur gran-
deur mais tout simplement parceque, dans ce livre, je m'interesse davan-
tage à l'homme, à sa place dans la société qu'aux constructions materiel-
les . Ce que construit l'homme est durable tandisque chaque frag-
ment de sa vie (fragment à la fois révélateur de la pensée humaine et
de l'action humaine) peut être ou perdu ou saisi dans l'espace d'une
seconde . Saisir cette fraction de seconde est , je pense,
le rôle le plus important du photographe .

Fig. 11 Henri Cartier-Bresson's afterword for the book that was to be published by Pantheon Books

Jean and Dido Renoir and Man Ray, while others were yet to be encountered, including William Faulkner (fig.10), Igor Stravinsky, Saul Steinberg and many more.[30]

After seventy-seven days of a long, exhausting trip, they arrived in New York on 5 July (two months after the Magnum co-operative was officially created) and went their separate ways. In *Sextet*, Brinnin devotes a fairly bitter chapter to his travels with Cartier, convinced that the photographer had sought to use him and then eliminate him from the resulting book. His account nonetheless provides us with numerous details of their everyday life, the artists they met, the way Cartier would calm down by reciting Mallarmé in the car and the way he took his photos.[31]

As usual, Cartier was impatient; the publication of the book was dragging on and Brinnin was annoyed because he had not been consulted about the layout of the photos (the mock-up, finalized by Brodovitch, has unfortunately been lost). He speaks of the choice of images as 'a study in morbidity amounting to a pathological casebook' and saw no sign of any space left for his essay, just a short foreword by Cartier.[32] (fig.11)

Concerning the 'bleakness' of Cartier's material, Arthur Miller wrote in the introductory text for his friend's 1991 exhibit on America, 'Cartier-Bresson was trying to get behind the glitz to the substance of American society. And since his is fundamentally a tragic vision he reacted most feelingly to what in America he saw as related to its decay, its pain.'[33] Here it should be noted that just before leaving, Brinnin took with him a copy of *American Photographs*: 'I made a last survey, picked Walker Evans's book of American photographs from a shelf and placed it face up on the backseat.'[34] Indeed, as Kirstein remarks in his essay, this book wasn't exactly cheerful either: 'There has been no need for Evans to dramatize his material with photographic tricks, because the material is already, in itself, intensively dramatic.'[35] If Cartier mentions in his short postface that he concentrated on people and took few photographs of monuments or other 'human realizations' like skyscrapers or bridges, we might imagine that he was also responding to Evans's book, where the two aspects were deliberately combined.

30 The itinerary basically went through Washington, D.C., to Tennessee, Mississippi and Louisiana. By mid-May they were in New Mexico, then went on to Los Angeles and San Francisco before doubling back through Colorado, Chicago and Boston. / 31 'Henri curbed his impatience by memorizing passages from a volume of Mallarmé which, with tears in his eyes, and a catch in his throat, he would recite for me....' *Sextet*, p. 140. / 32 Ibid., p. 157. / 33 Arthur Miller, introductory text for 'L'Amérique furtivement', an exhibition presented at the Fnac-Étoile, Paris, 14 November 1991–18 January 1992. / 34 *Sextet*, p. 107. / 35 *American Photographs*, p. 197.

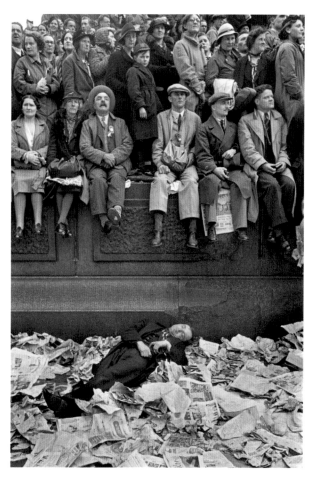

Fig.12 Coronation of King George VI, Trafalgar Square, London, 1937
(Henri Cartier-Bresson)

Several exchanges — in English — of letters between Brinnin and Cartier attest to the latter's good faith: 'I am surprised at you reproaching me of having decided on the choice of photos without you, I can only say that it would never occur me to suggest any changes in the wording of your text.'[36] At that point, Cartier had to leave: he was expected in India — since the official creation of Magnum, its founders had 'divided up' the world.[37] He and his wife thus set out for Asia, arriving in Bombay in October, one month after the beginning of decolonization. They were to remain there for three years.

On 24 August 1948, eleven months after they had left the United States, Cartier wrote to his sister Nicole from Delhi, begging her to look after the book about America: 'I don't know who I can confide in except you. The very last chance not to let this work go mouldy, like an old manuscript in a cupboard where our little nephews hunting for jam will discover it, depends on you. . . . The last I heard is that Paulhan wants to have it published by TEL with a text by Sartre. . . . go and see Sartre, Paulhan (I'll send him a note) or whoever you think is worthwhile.'[38] We don't know whether Nicole Cartier-Bresson did in fact move heaven and earth for this project, but it was clearly not set aside by its author.

On his return from Asia, Cartier-Bresson worked with the publisher Tériade on *Images à la sauvette*, a book which was probably as important for him as *American Photographs* was for Evans. Published in the United States as *The Decisive Moment*, it received a favourable review in the *New York Times* from none other than Walker Evans. 'Cartier-Bresson was and is a true man of the eye,' he wrote. 'More, he was one of the few innovators in photography.'[39] (fig.17)

RELATIONS BETWEEN CARTIER AND EVANS

In *Modern Art and the New Past*, James Thrall Soby describes Evans's visit to Julien Levy's gallery: 'That same year, 1933, he saw Henri Cartier-Bresson's show of Leica snapshots at Julien Levy's gallery in NY... Evans said that for the first time he could understand fully the immense potentialities of the hand

36 Letter written to Brinnin from New York, 6 September 1947. Fondation HCB archives, Paris. / **37** The certificate of incorporation of Magnum Photos, Inc. was officially filed on 22 May 1947 by founders Capa, 'Chim, Seymour, Cartier, Bill and Rita Vandivert, and George Rodger, who was to join them later. / **38** Fondation HCB archives, Paris. TEL: one of the series published by Éditions Gallimard. / **39** *Images à la sauvette* was published by Tériade in Paris in 1952 and *The Decisive Moment*, by Simon & Schuster in New York the same year. Evans's review appeared in the *New York Times* on 19 October 1952.

camera operated at split-second speed.'[40] It was a shock for many photographers, who immediately understood the freedom of movement offered by the Leica, but above all the virtuosity of the person using it. In 1969, when Evans was asked to present a section on photography for the book *Quality, Its Image in the Arts*, he wrote a brilliant introduction speaking of the emergence of non-commercial photography and the fact that, 'Modern photographers who are artists are an unusual breed.'[41] Among the twenty or so photographs selected was Cartier-Bresson's image taken at the coronation of George VI in London in 1937 (fig. 12). 'The picture shown here defies analysis,' Evans commented. 'It is by Henri Cartier-Bresson who is surely the bravura photographer of the time. Cartier has always been a kind of spirit medium: poetry sometimes speaks through his camera.'[42]

The two men met several times, first in 1935 in Greenwich Village with Helen Levitt, when they were preparing their joint show at the Julien Levy Gallery, and then at different New York events over the years. In one of his lectures at Yale, Evans described Cartier as a shy, reserved man who did not speak a great deal. For his part, Cartier said of Evans that he inspired respect. Peter Galassi reports that during the opening of Cartier-Bresson's 'Recent Photographs' exhibit at MoMA in 1968, then chief-curator of photography John Szarkowski saw the two 'monsters' watching each other closely in a kind of 'religious, distant observation.' There were never any emotional demonstrations between them but a profound mutual respect which was punctuated in later years by exchanges of books.

Cartier-Bresson often cited Evans's *Girl in Fulton Street* (p.51) as an essential image for him; Evans was one of the rare photographers (along with André Kertész and a few others) who really mattered to him. He did not like to talk about photography – which was, he reckoned, a medium less rich than painting, music or literature. Nonetheless, as Kirstein maintained in the 1947 MoMA catalogue, 'It has taken us too long a time to discover that the most impressive and lasting achievements of the camera are in pictures, snapped from impartial history, which could not have been realized in any other medium. Cartier-Bresson's best shots could not have been drawn or painted, but only photographed.'[43]

40 James Thrall Soby, *Modern Art and the New Past* (Norman, Oklahoma: University of Oklahoma Press, 1957), pp. 170–171. / 41 Louis Kronenberger (ed.), *Quality, Its Image in the Arts* (New York: Atheneum, 1969), p. 169. / 42 Ibid., p. 190. / 43 *The Photographs of Henri Cartier-Bresson*. p. 11.

Cartier's travels in America as an outside observer left him with a deep interest in the country, especially New York, which was a source of stimulation for him. He never forgot that it was in the United States that he was recognized as the 'Artist with a camera'.[44] This was the first time he undertook a major project – even if it did not result in the book he was hoping for – and, in the course of the trip, he put together a series of photographs with the clear desire to assemble a group of 'notes', a reportage à la Cartier-Bresson, with no claim to exhaustiveness. Some of his images have become icons, others, although they were printed for the book at the time, have never been seen.

Evans, the inside observer, at the peak of his art, knew better than anyone how to capture an image of the United States with brilliance and simplicity, which was the perfect achievement of his 'credo': making visible what the present will look like as the past. A decade later, in 1956, Evans was to defend the candidacy of a young Swiss photographer, Robert Frank, for a Guggenheim Fellowship. The project, entitled 'The photographing of America', was to become *The Americans*, published in France exactly fifty years ago.[45]

The twenty-first century is still feeding on these two geniuses of the past century, whose ART has, in spite of them, perpetuated their vision. For Evans and Cartier alike, the category of art represented an insignificant, if not negative, issue. This attitude, somewhat distant – or proud – is perfectly embodied in Evans's remark that, 'The real thing that I'm talking about has purity and a certain severity, rigor, simplicity, directness, clarity, and it is without artistic pretension in a self-conscious sense of the word.'[46]

This encounter between the two men, on the occasion of the centennial of Henri Cartier-Bresson's birth, offers a confrontation of their ways of seeing, with all of their differences, but also in the sharing of a keen consciousness of the world, be it near or far away, and the insatiable pleasure of the eye.

Agnès Sire
Curator of the exhibition

44 Kirstein's expression, which became the headline of his article published in the *New York Times* on 2 February 1947 for the MoMA show. / 45 On Evans's support for Frank, see *Unclassified*, p. 85 ff. The final book was first published in France as *Les Américains* (Paris: R. Delpire, 1958). / 46 'Lyric documentary', excerpt from Evans's lecture at Yale on 11 March 1964, reproduced in Walker Evans at Work, p. 238.

Art historian and critic Jean-François Chevrier has taught at the École nationale supérieure des beaux-arts in Paris since 1988. He was the founding editor of *Photographies* magazine (1982–1985) and consultant for Documenta X (1997) and has curated numerous international exhibitions including: *Une autre objectivité/Another Objectivity* (1988–1989), *Photo-Kunst* (1989–1990), *Walker Evans et Dan Graham* (1992–1994), *Des territoires* (Paris, 2001), and *L'Action restreinte. L'art moderne selon Mallarmé* (2004–2005). He is the author of a monograph on Jeff Wall (Hazan, 2006) and is presently preparing an exhibition on 'The Artistic Hallucination. From William Blake to Sigmar Polke'.

A DIALOGUE? Jean-François Chevrier

The dialogue which got underway between Evans and Cartier-Bresson in the early 1930s was one of the high points in the historic exchanges between Paris and New York. It may have begun in Paris, at the end of the 1920s, when the two photographers had not yet met each other, but it pursued its course in the United States. It came to public attention through joint exhibitions and a few declarations of mutual admiration. But it took shape above all in picture form, where the two artists occupied similar positions within the context of different but complementary experiences. And the final episode of this dialogue, consistent with to its historical logic, took place in the United States in 1947, after Cartier-Bresson's retrospective at the Museum of Modern Art, when he undertook a photographic journey throughout the country, in collaboration with a writer, to make a book, in the spirit of Evans's collaboration with James Agee in summer 1936 (which resulted in *Let Us Now Praise Famous Men* in 1941 (fig. 13)). What happened afterwards is not directly relevant to the exhibition that has prompted this essay, but it necessarily colours my point of view, insofar as it largely determined the two artists' legacy and what they represent today.

Evans and Cartier-Bresson have one essential point in common, which was almost immediately recognized in New York (and ignored in Paris): they became artists by reinventing photography. The former had (timidly) tried his hand at literature, the latter had studied painting. Both discovered the possibilities of photography by practising it more than learning it. In 1935 the New York gallery owner Julien Levy brought them together through the idea of an 'anti-graphic' photography. This term is misleading because there are few photographers whose images present such a drawing-like quality (not to mention Cartier-Bresson's practice as a draughtsman). But Levy's expression at least serves to designate a historical fact: Evans and Cartier-Bresson freed photography by distancing themselves from the norms of the beautiful image, whether this was composed, in the fine-arts tradition, or constructed according to the principles laid out by the functionalist, professionalized Constructivism of the 1920s. Evans was more conscious, more thoughtful. He took a stand in critical essays and methodically considered the respective contributions of the European avant-gardes, an effort made possible in part by the surveys organized at the Museum of Modern Art. Cartier-Bresson did not have access to such a favourable institutional context within French culture at the end of the 1920s; significantly, it was in New York that he was seen and understood, situated and encouraged. On the other hand, Paris had offered him a direct experience of Surrealism (which was also determinant for Evans, at least as an alternative to Cubism). He had firmly understood that photography was not an art in itself, that it was situated between painting (or graphic arts) and film.

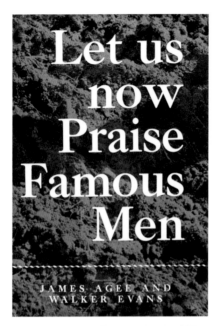

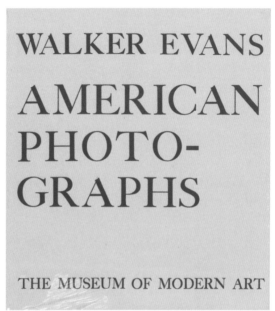

Fig. 13 *Let Us Now Praise Famous Men*, Houghton Mifflin / Mariner, 1941

Fig. 14 *American Photographs*, The Museum of Modern Art, 1938

Their respective bodies of work were constituted through several books which are now quite rightly held to be monuments of the history of photography and modern art. In 1952, Tériade published a large album of Cartier-Bresson's photographs with a cover by Matisse: *Images à la sauvette* (Paris: Éditions Verve) which also appared in an English edition as *The Decisive Moment* (New York: Simon & Schuster). Evans, for his part, had published *American Photographs* (fig. 14) at the Museum of Modern Art in 1938. The book accompanied an exhibition but had its own logic. The author of the essay, which came after the photos, was Lincoln Kirstein, who was to write the introduction to Cartier-Bresson's catalogue for his exhibition in the same museum a few years later. In 1966, Evans published a second book, *Many Are Called*, which has no equivalent in Cartier-Bresson's bibliography, and the same year, *Message from the Interior,* in collaboration with John Szarkowski. In 1941 he had published in book form the original layout – also used for the second edition in 1960 – of the investigation on the rural South carried out six years earlier with James Agee. In 1947 Cartier-Bresson set out on his own journey with John Malcolm Brinnin after receiving publication guarantees, but the book never saw the light of day. *The Decisive Moment i*s another story altogether. Cartier-Bresson wrote the text himself (at Tériade's suggestion). A short disclaimer at the beginning of the album section warns, 'These photographs taken at random by a wandering camera do not in any way attempt to give a general picture of any of the countries in which that camera has been at large'.

This declaration is a reaction to the failure of the 1947 book project and marks a departure from *American Photographs*. But it also shows that Cartier-Bresson had kept in mind the model of the book as a monographic description of a territory. *The Decisive Moment* is more anti-geographic than anti-graphic. Kirstein's essay in *American Photographs* is entitled 'Photographs of America: Walker Evans', while that of Cartier-Bresson's catalogue is 'Henri Cartier-Bresson: Documentary Humanist'. The distance between the two says a great deal. It is historical: just after the Second World War, it was impossible to emphasize a national 'interest' (in every sense of the word). Humanism was intended to cross borders and surmount particular cultural features, in art and politics alike. In fact, Evans himself had chosen the title *American Photographs*, and not 'photographs of America'. For him, it was not a question of sketching the portrait of a country; the book was rather a skilfully organized, sequenced collection of pictures which had in common the fact of being taken *in* a country rather than dealing *with* it. *American Photographs* was a late reaction to the books inspired by the Great Depression, which wound up constituting a kind of standard for the photography book cum essay.

We know that Evans was irritated to discover the publication of the book Margaret Bourke-White had done with Erskine Caldwell, *You Have Seen Their Faces* (1937), while he had not been able to publish his

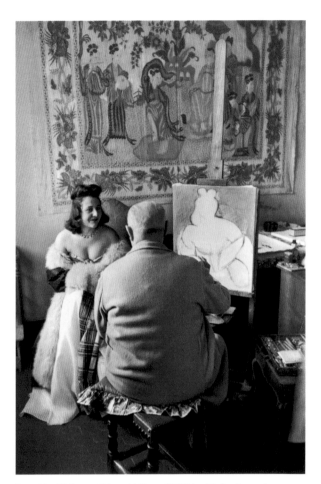

Fig. 15 Henri Matisse and his model, Vence, 1944 (Henri Cartier-Bresson)

collaboration with Agee. Bourke-White, *Life*'s foremost photographer, was Evans's nemesis; in his eyes, she represented the classic anti-artist, the eye-catching mixture of the sentimental and the sensational (or the spectacular) – in other words, what the top illustrated magazines encouraged and what he rejected. Giving his book the title *American Photographs* meant putting photography in the forefront and address-ing himself to a *viewer*; it meant inviting the reader to look at the images reproduced as photographs and not simply as the illustrations or backdrop of a predefined message. The same year, the poet Archibald MacLeish published *Land of the Free*, which was intended to reverse the traditional relationship between text and image. At the outset, he said, images from various sources – including three by Evans – were supposed to serve as a 'commentary' on the poem but he ultimately decided to privilege the images, which he termed 'vivid American documents', and thus arrived at the idea of a 'book of photographs illustrated by a poem'. Evans belonged in part to this tradition, but he spoke of 'photographs' rather than 'documents' and presented them alone, one after the other, without an accompanying text. In short, the argument of Evans's book was in the pictures, the way they were organized and sequenced and the net-work of motifs modulated from one to the other. This modulation was the key, what gave the images their resonance within the book's total *volume*.

The distance which Cartier-Bresson took in 1952 relative to the 1930s tradition of the picture book – which had culminated in *American Photographs* – must therefore be qualified. But the difference which still remained was not new. Kirstein had already noted it, and implicitly remarked its historic nature, in 1947, with the idea of 'documentary humanism', as opposed to Evans's 'American documents', where the environment of Middle America was as present as its inhabitants. The picture published facing his text takes the reader into another context, one which is close in time and distant in space; captioned 'Henri Matisse in Vence (Alpes Maritimes), 1944' (fig. 15), it shows the painter seated, seen from behind, monumental, in the process of drawing from a model. Evans and Cartier-Bresson quite obviously shared a commitment to clarity and terseness, as opposed to the rhetorical effects and gimmicks of art photo-graphy; Kirstein recalls the impasses of Pictorialism, moreover, in his rapid survey of relations between painting and photography. The portrait of Matisse illustrates the complexity of these relations by re-placing the painter-portraitist's face with that of his model. The photographer himself was invisible to the painter but the woman posing reacts to their double presence; from her smile, we can deduce that the painter was speaking to her but this smile is frozen by the camera, like a mask which echoes the man-nerism of the hairstyle and the costume. The photographer has introduced himself as an (invisible) third party in the dialogue between the painter and his model. Placed just before Kirstein's essay, the portrait

Vinegrower of Touraine, France, 1946

54

Mme Lanvin, Paris, 1945

55

Fig. 16 Double-spread of the exhibition catalogue of Henri Cartier-Bresson's retrospective at MoMA, 1947

identifies Matisse's work as an example for Cartier-Bresson's conception of photography: by concentrating the specific circumstances of a sitting into the vision of an instant (the famous 'decisive moment'), the photographer has seized the Mannerist, even grotesque aspect of an art reputed for its qualities of serene, measured clarity. A photographic style, based on just the right distance from an empathetic irony, manifests itself in the mirror of the painterly arabesque. The Oriental tapestry on the wall, behind the model, with its ornamental border, emphasizes the dimension of the arabesque underlying Matisse's decorative mode and fluid line.

In his essay, Kirstein indicates how the mechanical, impersonal nature of photographic recording was for Cartier-Bresson – and, I would say, for Evans as well – the prerequisite for an art of expression or individual interpretation: 'Cartier-Bresson feels that an insistence on the direct and indirect documentation of human behavior by the camera offers an unlimited field of investigation for individual photographers, and of infinite differences of personal comment.' We might add that this personal interpretation of 'human behavior' is the result of a more general, anonymous mimetic faculty, where the camera, in the photographer's hands, serves as the operational tool, analogous to the painter's brush. Matisse himself often mentioned the schematization process in the portrait, which, as Cartier-Bresson's photo suggests, oriented his own form of expression. This schematization consisted of capturing an asymmetry proper to the model. As Matisse remarked at the end of his life, 'I finally discovered that a portrait's likeness comes from the opposition between the face of the model and the other faces: in a word, its particular asymmetry. Each face has its particular rhythm and this rhythm is what creates the likeness.'[1] And this is exactly what appears in the photo taken in Vence in 1944. By placing himself behind the painter, by looking over his shoulder, as it were, the photographer has captured the model's profile outlined by the light. Matisse's reflections on the art of the portrait, carried out in words and actions, is actually extraordinarily complex; it implies a process of identification (or self-projection into the other) which involves the unconscious but controlled work of the hand. The photographer has a mechanical eye which is fairly voracious, but his obligation to satisfy the machine encourages artifice.

1 Matisse adds here, 'For Westerners, the most characteristic portraits are done by the Germans: Holbein, Dürer and Lucas Cranach. They play with the asymmetry, the dissimilarity of the faces, unlike the Southern Europeans, who most often tend to reduce everything to a regular type, a symmetrical construction.' Preface to Henri Matisse, *Portraits* (Monte-Carlo: éditions André Sauret, 1954), in Henri Matisse, *Écrits et propos sur l'art*, ed. Dominique Fourcade (Paris: Hermann, 1972), p. 177. A few lines earlier in the same preface, Matisse recalls how and why he used photography: 'I've carefully studied the representation of the human face through pure drawing, and in order to avoid giving the result of my efforts the nature of my personal work – in the same way that a portrait by Raphael is above all a portrait by Raphael – I did my best, around 1900, to copy faces literally from photographs, which kept me within the limits of the visible nature of a model. Since then, I've sometimes repeated this way of working. While keeping to the impression a face produced on me, I tried not to stray from its anatomical structure' (ibid., pp. 176–177).

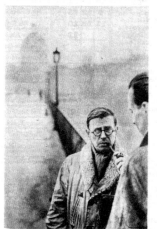

"Matisse...1952...looking at two vases by Picasso."

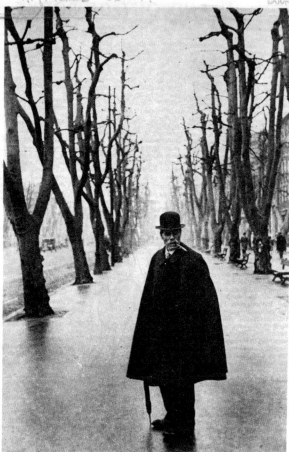

"Jean-Paul Sartre on the Pont des Arts, Paris, 1946."
[For news of Sartre, see p. 40 of this issue.]

"Allee du Prado, Marseille, 1932. I was walking behind
this man, and for some reason he stopped and turned."

Photographs by Henri Cartier-Bresson for "The Decisive Moment."

Cartier-Bresson, a True Man of the Eye

THE DECISIVE MOMENT. Photography by Henri Cartier-Bresson. Introduction by Henri Cartier-Bresson; technical note by Richard L. Simon. 126 plates. New York: Simon & Schuster, in collaboration with Editions Verve of Paris. $12.50.

By WALKER EVANS

IN the Nineteen-Thirties Henri Cartier-Bresson, an extremely intelligent young French photographer-at-large, was discovered and discovered by this and that local esthete of influence. He was relatively unharmed by the experience.

The esthetes were right. Cartier-Bresson was and is a true man of the eye. More, he was one of the few innovators in photography. The words of this title, "The Decisive Moment," point out that innovation. What Cartier-Bresson has is a more or less dependable ability to snap a picture *just*

when, say, a city neighborhood roughneck becomes the universal dark character planted in the perfect setting for his type; *just* when a child takes off into an ecstatic state of being as he skips beside a wall that is covered with an unearthly design of some lunar-like patina. This picture field was not Cartier-Bresson's exclusive discovery. But his unmuddled assumptions about it when he found it, and his continuity of performance in it, were important.

In another realm, picture reporting, Cartier-Bresson seems to answer the magazine editor's dream of sending out a photographer who, even though hampered by originality, will bring in

Mr. Evans is a photographer and writer now on the staff of Fortune.

the definitive summation of a topical event. See the famous snapshot, in his George V Coronation series, of the waiting English crowd; this is assuredly the most staggering piece of camera humor-cum-characterization ever published.

CAMERA portraiture of celebrities is the riskiest of fields: people are so ready to look at the famous that the artist is tempted into mere photographic name-dropping. Cartier-Bresson can stumble over this too: his picture of Saul Steinberg, though mildly witty, seems nothing much. But look at his Bérard, look at his Matisse and at his Sartre in this book: "Bébé" Bérard awash in his hotel bedding, underwriting the occasion with uproarious, mock-narcissistic collaboration, the

whole thing a lesson in how to give odor full and high to a photograph; Matisse at his easel in Vence, on the French Riviera; a facing portrait of the same artist, admiring the work of Picasso—and showing that admiration with a gesture that no one but a Frenchman could duplicate; Sartre in conversation, out somewhere in the soft Paris air—perhaps the best of the portraits. I happen to think that if you must photograph personalities, this neo-newspaper style is the way to do it.

This book, manufactured in France, is a stunning production. The plates are heliogravure of breath-taking quality. Cartier-Bresson's fourteen-page preface essay has something rather peculiar about it, for writing of this kind: it is quite devoid of rubbish and ego.

Fig. 17 Article by Walker Evans published in the *New York Times*, 19 October 1952

It is significant that the 1947 MoMA exhibition, from what we can see of it in the catalogue, promoted an art of portrait photography, combined with a fairly sombre, tragic vision of circumstances where human dignity and grace are generally (i.e., in their generality as well) expressed. Of the forty pictures re-produced in the album section of the catalogue, more than half are portraits, including seven, grouped together at the end of the volume, which show prominent representatives of French culture, from Marie and Pierre Joliot-Curie (p. 46) to Mme Lanvin on the last double page (p. 55), placed opposite a 'Vine-grower of Touraine' (fig.16). A second portrait of Matisse in Vence (p. 50), the famous one with the doves, appears opposite one of the only two views of objects, but this one – the other shows a display of fresh fruit in Italy – presents a group of items on a table in Picasso's bedroom (p. 51). We obviously have to take into account the choices of the editor, who was presenting an artist unknown to the general public in New York. But all of these figures, beyond the fact of recalling to New Yorkers a world which had been inaccessible to them for four years, are permeated with a gravity and tragic, sometimes melancholic tone at the opposite end of the scale from Matisse's serenity. The caption to the portrait of Braque, his head tilted thoughtfully, indicates that he was photographed at home on the day of the Allied invasion of Normandy (*Georges Braque in his home in Paris, D-Day, 1944*). Paul Claudel is seen walking past a hearse in the village of Brangues. Pierre Bonnard, grown old, also seems attentive to some invisible event, sitting on the edge of the bed, somewhat distant, with his body bent over and a scarf knotted over his plain jacket. The making of history runs through these pictures, shaping faces and demeanours: the documentary humanist works under its dictates and for it (producing traces which will be readable later on), against time, destruction, forgetting. For Kirstein, the image of the children playing in the ruins, taken in 1933 in Seville, was a prophecy of the disaster to come: the holes in the plaster wall 'seem torn out of the paper on which they are printed'.[2]

In the 1930s and 1940s, the portrait of prominent figures and the experience of the new reign of terror in Europe were distinctive features of Cartier-Bresson's work which are not found in that of Evans, who ignored Europe and chose to concentrate on an anonymous American subject matter excluding the

2 'No image since,' he adds, 'has provided such a powerful report of fused innocence and destruction, of fun and fright.'

journalistic chronicle (even of cultural life). The review of *The Decisive Moment* that he wrote for the *New York Times* clearly brings out these differences (fig.17). His first comments bear on the achievements of his friend and partner from the 1930s, recognized, he recalls with a touch of irony, by 'this and that local esthete of influence' (i.e., the same New York critics who had defended Evans, such as Kirstein or Julien Levy). This man, who always found the right moment, was worthy of their respect: 'The esthetes were right. Cartier-Bresson was and is a true man of the eye.' He then turns to the domain of what he called 'picture reporting' and singles out the picture of the London crowd at Trafalgar Square during the celebration of the coronation of George VI, with the sleeping man lying on a mattress of newspapers in the foreground: 'the most staggering piece of camera humor-cum-characterization ever published'.[3] (fig.12) He concludes his rapid survey with the 'riskiest of fields', celebrity portraits. That of Saul Steinberg seems to him – rightly – to be too facile, in keeping with the conventions of the genre, but he praises the two portraits of Matisse: the one reproduced at the beginning of Kirstein's preface in the 1947 catalogue and that of 1952, where Matisse shows his admiration for a vase decorated by Picasso 'with a gesture that no one but a Frenchman could duplicate'. After vaunting the portrait of Sartre on the Pont des Arts ('perhaps the best of the portraits'), he concludes that '. . . if you must photograph personalities, this neo-newspaper style is the way to do it.'[4]

It must also be pointed out that the *New York Times* review does not contain a single word on the second part of the book, devoted to the reportages in Asia which were produced in the context of Magnum Photos. This silence, which we have no reason to attribute to a decision of the newspaper, indicates a divergence between the two photographers. Evans had chosen to limit his scope to a close field of enquiry while Cartier-Bresson had opted for reportage in distant countries. The first part of *The Decisive Moment* thus corresponds to their common choices in the 1930s but the second – where a single photo dating from before 1947 (a view of the Loire Valley from 1946, no. 108) – belongs to another time. For Cartier-Bresson, the world had changed with the Second World War. Robert Capa had convinced him to choose reportage in order to avoid locking himself into the narrow (and outdated) world

3 Many years later, in 1969, Evans chose this same image to accompany his essay on photography in the book edited by Louis Kronenberger, *Quality, Its Image in the Arts* (New York: Atheneum). / 4 It appears that Evans did not try to apply Cartier-Bresson's solution himself. It should also be made clear that, contrary to the professional stance Evans attributed to him, Cartier-Bresson rarely made portraits of personalities he did not know personally, or whose work he was unfamiliar with.

of the Surrealists.[5] He had always been attracted by the East. Current events, often tragic, in these immense regions at the beginnings of decolonization and the Cold War – the Middle East, India, China (in revolution), Indonesia (newly independent) – let him satisfy this attraction, as well as a need to bear witness.[6] The two sections of *The Decisive Moment* reflect a division of the world dictated by historical events as much as the indication and interpretation of a biographical division. We might also conclude that the strict equality of the two sections (in terms of the number of pictures) materializes, within the volume of the book, a moment of equilibrium, one which Evans was neither able nor willing to recognize. The divergence of the two bodies of work may well have been precipitated by the failure of Cartier-Bresson's American book project. But it was inherent in the distance between two individual itineraries and two cultures. For Cartier-Bresson, Matisse's arabesque was the fluidity of lines and bodies introduced into geometry, but also a sensual, spiritual response to the chaos of the world. Matisse sometimes said that the 'revelation' of colour and 'a larger space, a veritable plastic space' came to him from the East.[7] The echo of this revelation is appreciable in Cartier-Bresson's work after the war. Evans, meanwhile, was always wary of a painterly seduction, the effects of which he had seen in the (overly) refined imagery of the Symbolist and Modernist photographers. Similarly, he had eliminated any trace of the great epic style from his poetic horizon by rejecting the tradition of the Sublime attached to the so-called frontier myth.[8] Evans favoured dense sequences of small images, analogous to prose poems; he distrusted the wide *view* over one or two pages of a magazine. Cartier-Bresson, conversely, sought this kind of spread. The second part of *The Decisive Moment* exalts the crowd and space, numbers and sprawl. Evans could not share this vision.

5 As Cartier-Bresson recounted the story to critic Hervé Guibert in 1980, 'Capa had told me, "Don't get labelled a Surrealist photographer. Be a photo-journalist, otherwise you're going to fall into Mannerism, preciousness. Keep Surrealism in your dear little heart. Don't fidget about, get going!" This advice expanded my horizons. I was married to an Indonesian woman and Capa said to me, "You deal with decolonization." I spent three years in Asia without coming back.' *Le Monde*, 30 October 1988, p. 18. / 6 Without going into details – which is unnecessary for the purposes of this essay – I would point out that between 1948 and 1950 Cartier-Bresson essentially went to explore and live in countries under British and Dutch domination, such as India and Indonesia, or Egypt, plus continental China, rather than those of the French Empire. He went to neither Vietnam nor Cambodia, nor Lebanon and Syria, the two countries of the Middle East which became independent in 1945. / 7 Matisse often indicated the importance his discovery of Islamic ornament at the beginning of the twentieth century had for him in his conception of relations between colour and space. He told art critic Gaston Diehl in 1947, 'If I instinctively admired the Primitives at the Louvre and then Oriental art, in particular at the extraordinary exhibit in Munich [autumn 1910], it was because I found a new confirmation there.' Mentioning Persian miniatures, he adds, 'Through its use of detail, this art suggests a larger space, a veritable plastic space. That helped me to get out of intimist painting.' *Art Présent* no. 2, reprinted in *Henri Matisse, Écrits et propos sur l'art*, p. 203. / 8 The frontier myth is an interpretation of the westward expansion advanced by American historian Frederick Jackson Turner (in a paper delivered at the Chicago Columbian Exposition in 1893), who maintained that this movement constituted the distinctive feature of United States history, its particular dynamics. For Turner, the frontier was synonymous with Americanization: the country was shaped by expanding the frontier of the (civilized) rural world conquered from the wild open spaces. This zone of conquest permitted a continuously renewed process of shaping the American social identity through the contact with untamed nature.

'For me,' Cartier-Bresson remarked in 1980, 'the nineteenth century ended around 1950–1955.'[9] The expression obviously alludes to the advent of consumer society, the spread of the 'American way of life' and – a particularly sensitive phenomenon for a photographer – the invention of the broadcast media (increasingly dominated by television). Evans, meanwhile, had to define his own working space, or find his place – which was impossible – in a picture industry which no longer had anything to do with the nineteenth century. In 1945 he resigned himself to working for the lavish *Fortune* magazine. In reality, he had never abandoned the impossible ideal of the 'independent' photographer, in the sense the word had acquired in French artistic culture of the second half of the nineteenth century. Depending on the circumstances, he contrasted art with photojournalism (Bourke-White) and the artist's freedom with the servile performances of the illustrator (Steichen), or reportage, identified with street photography, with art. In the latter case, 'art' signified galleries and museums, a closed system akin to that of the official salons of the nineteenth century, which had been contested by the 'independent' artists. The nineteenth century might have ended earlier for him than for Cartier-Bresson, but it also lasted longer. From the beginning of the 1930s, with his participation in Roy Stryker's investigation of the effects of the Depression in rural America, he had undertaken a kind of critical archaeology of the American way of life, at the very time this idea was emerging. And he did so by cobbling together an amazing counter-model: a mixture of independent art and French-style avant-gardism, Cubism and Surrealism, grafted onto an anti-modernist mythology where Atget's Old Paris met up with the eclectic American architecture of the nineteenth century.

The America Cartier-Bresson visited in 1947 was that of Evans, with more people and less architecture, or a broken architecture composed of the ruins of *American Photographs*, but combined with bodies. The difference is particularly noticeable if we compare Cartier-Bresson's photographs of New Orleans with Evans's views of the same places. In *American Photographs*, Evans had split his subject in two: people in the first part, houses in the second. This separation invited the reader-viewer to decipher the signs in order to answer the nagging question: Who lives where? What does it means to live somewhere? The

9 Guibert interview in *Le Monde*, p. 17.

empty interiors were placed in the first part. Atget had proceeded in a similar way by showing deserted streets and separating – or sometimes grouping together – bodies and settings. Like Atget, Evans conceived the photographic shot(s) as an act of collecting, and *American Photographs* is, among other things, an allegorical meditation on the collector's melancholy. Because the collection, like the allegory, is an impossible attempt to constitute a whole out of essentially discontinuous, fragmentary givens. It deals with a world in ruins: Evans was obsessed by dilapidation and social decline; the word 'decay' turns up constantly in his working notes from the 1930s.[10] This allegorical intention is nowhere to be found with Cartier-Bresson, who was looking for the miracle of the unique, complete, autonomous image independent of discourse. Evans could settle for a geometry dictated by the architectonic, or architectural structure of his subjects. Similarly, a simple frontal reproduction could satisfy him if the view was sufficiently interesting in itself and if the image could be integrated , through sequencing – or, more simply, collecting – into a significant whole.[11] By disappearing behind the camera, he countered the sophisticated ways of art photography with the photographer's anonymous skill and the strangeness of the likeness. We might even say that he conferred new artistic dignity on the concept of *reproduction*, which had been consistently discredited within the ranks of the fine arts in order to exclude photographers. Cartier-Bresson believed above all in the disciplined mobility of the eye. His 'American photographs' of 1947 are haunted by the movies; they are notes for a future film, which no writer, and certainly not the one he was associated with, was capable of scripting. Ultimately, the distance from Evans's approach in *American Photographs* is more appreciable than the points of proximity. Cartier-Bresson came after Evans, on the terrain of an adopted language, and he did not publish the French equivalent of Evans's book (partly because he did not find the equivalent of Kirstein and Agee in his own country). On the other hand, we can see just how much literature and film, more than painting or drawing, constituted an area of shared interests for the two photographers.

Photography, Evans observed, 'seems to be the most literary of the graphic arts.'[12] Surrealism had taught Cartier-Bresson to believe in coincidences and he constantly referred to 'objective chance'. Breton had

10 On this point, see my essay, 'Walker Evans, American Photographs et la question du sujet', *Communications* no. 71 (Paris, 2001), pp. 94–101. / 11 Cf. Kirstein's observation: 'Physically the pictures in this book exist as separate prints. They lack the surface, obvious continuity of the moving picture, which by its physical nature compels the observer to perceive a series of images as parts of a whole. But these photographs, of necessity seen singly, are not conceived as isolated pictures made by the camera turned indiscriminately here or there. In intention and in effect they exist as a collection of statements deriving from and presenting a consistent attitude' (*American Photographs*, pp. 192–193). / 12 Walker Evans, 'Photography', in *Quality*, p. 170.

put forward this idea – borrowed, he said, from Engels – in *Les vases communicants* (The communicating vessels, 1932), when he was attempting to reconcile dream and action, the Surrealist 'marvellous' and the Marxist dialectic, individual adventure and historical necessity. The so-called 'objective' chance was chance objectivized in a necessary poetic occurrence, in other words, reintegrated into a purposeful order. Even after the Second World War, Cartier-Bresson must have still imagined that photojournalism would allow him to fulfil this paradoxical programme. Evans, meanwhile, had discovered photography in another literary context. His first collaboration with a writer was the illustration of Hart Crane's poem *The Bridge*, after which he worked with James Agee. And if the reportage he made in Cuba in 1933 cannot be seen as the decisive turning point in his life's work, it is clear that the example of the spare, factual prose of Ernest Hemingway – whom he met at that time – was determinant. But beyond these differences, Evans and Cartier-Bresson had found a common ground in the work of Joyce. They had read *Ulysses*, which was for both of them a shared language, an immense territory of verbal adventures, the imaginary space of a Dublin, at once mythological and mundane, recreated through memory. In the 1930s their world was urban: they had seen Atget and Cubist painting; Evans was interested in signs (both literally and figuratively) and inscriptions, Cartier-Bresson less so. But both men explored what Joyce called the 'ineluctable modality of the visible', at the edges of the city and in its pockets of obscurity, its *flashes*.[13]

At the end of the 1930s, after his MoMA exhibit, when fascism and horror were taking hold of Europe, Evans began photographing passengers in the New York subway with a hidden camera. *Many Are Called* was not published until much later, in 1966, but the pictures reflect the anxiety of the period just before the war. With his collection of anonymous portraits, Evans broke up the city crowd by interrupting the filmic continuity produced by the movement of the train. The systematic nature of the procedure brings out the singularity of the faces against a backdrop of distanced pathos. This distance is also a defining feature of in Cartier-Bresson's work, although he privileged improvisation, in the musical sense of the term, over variations on a theme. Both were interested in the ritualized forms of social life,

13 See the first line of Stephen Dedalus's inner monologue in Episode 3 of *Ulysses* ('Proteus'): 'Ineluctable modality of the visible: at least that if no more, thought through my eyes. Signatures of all things I am here to read, seaspawn and seawrack, the nearing tide, that rusty boot.'

with a common awareness of the decline of religion. Evans spoke of 'religion in decay' in a 1934 letter.[14] But he did not rejoice over this decline; he photographed the little wooden churches in the South with respectful attention devoid of emphasis. His pictures of farmhouse interiors reflect the sacred nature of a domestic space where poverty, in the absence of any decorative excess, is transformed into asceticism. His choice of clarity and sobriety cannot be limited to any 'form equals function' ideal. His taste for eclectic decoration made him permanently immune to the functionalist dogma underlying the International Style (which had received its consecration at MoMA, where Evans himself had privileged access).[15] But he continued his quest for visual simplicity corresponding to the state of things, corresponding to poet William Carlos Williams's principle of 'No ideas but in things'. When he made the extraordinary portfolio *Beauties of the Common Tool*, published in *Fortune* in 1955, he gave the tools a hieratic quality which contradicts both the sophistication of design and the nostalgia of pre-industrial folklore (or the romantic myth of the machine): abstracted from their functional environment, the tools appear in a superb isolation which makes them resemble the African art objects he had photographed several years earlier for a MoMA exhibition. As he wrote in *Fortune*, 'Among low-priced, factory-produced goods, none is so appealing to the senses as the ordinary hand tool. Hence, a hardware store is a kind of off-beat museum show for the man who responds to good, clear, "undesigned" forms. ...'[16]

Probably because he had little interest for objects, or because he was cured of Surrealist discovery, because he was not keen on collecting, or perhaps because he distrusted exoticism in the camera, Cartier-Bresson – at the risk of subscribing to another exoticism – sought to capture the sacred in gestures and bearings more than in things. One of his most famous photos, taken in Kashmir in 1948, shows Muslim women 'praying – according to the caption in *The Decisive Moment* – toward the sun rising behind the Himalayas'. Captured in the great silence of the dawn, with a sumptuous landscape below them, this small group of women stands out from the crowd of people in the surrounding images. The reader who leafs through the second part of *The Decisive Moment* moves about in the noises and organized cacophony of a 'silent' film.

14 Draft of a letter to Ernestine Evans, February 1934, reproduced in Jerry Thompson and John T. Hill (eds), *Walker Evans at Work* (New York: Harper and Row, 1982), p. 98. / 15 The exhibition 'The International Style', organised by Henry-Russell Hitchcock and Philip Johnson, was presented at MoMA in 1932, with an accompanying book published by W. W. Norton. A second, expanded edition was brought out in 1966. / 16 The text continues, 'Aside from their functions – though they are exclusively wedded to function – each of these tools lures the eye to follow its curves and angles, and invites the hand to test its balance. ... In fact, almost all the basic small tools stand, aesthetically speaking, for elegance, candor and purity.' Walker Evans, *Fortune*, July 1955, cited in Lesley K. Baier, *Walker Evans at Fortune 1945-1965* (Wellesley, Mass.: Wellesley College Museum, 1977), p. 50.

In *American Photographs*, crowd scenes are rare. Evans has privileged signs inscribed in things and things transformed into signs. He likes aligned figures, like Joyce's 'whitesmocked sandwichmen' in Episode 8 of *Ulysses* whose boards are marked with individual letters forming a word in the street. The alignment of the houses on Main Street is the model of a crowd walking in procession. The inhabitants appear in the doorways, in front of the shops — especially the farmers without work and the population of the black neighbourhoods, victims of the economic crisis. The doorway is at once the space of community rituals of self-representation and the metaphor of the portrait as the evocation of an inaccessible inner existence. In *Let Us Now Praise Famous Men* (fig. 16), the front porch is the ideal place for the family portrait. For Evans and Agee alike, the house was a sacred refuge, set firmly on the ground, silent – Agee has described the modulations of silence – like the picture on the page. Inside, the chimney forms an altar; in an openwork passageway, household objects (a bucket and a hanging cloth) recall the symbols of a fifteenth-century Annunciation. The (uncredited) quotations from William Blake in one of the appendices confirm Agee's frenetic attempt to set humble, ordinary things in poetic Christian terms. Like Cartier-Bresson, Evans liked to think he was protected from any risk of religious nostalgia, and any poetic frenzy. But his rejection of Philistinism should not be reduced to a traditional stance of the bohemian elite: it partakes of a confidence in the redemptive transcendence of art.[17]

With Cartier-Bresson, this spiritual dimension is conveyed above all in the *composition*. He seeks the miracle which condenses a situation into an instantaneous configuration. Carl Einstein's novel *Bebuquin*, published in 1912 (but completed three years earlier), was subtitled *The Dilettantes of the Miracle*. There is something of that with Cartier-Bresson, and even more with his imitators, who have taken his methods for recipes. But he distrusted coincidences reduced to the seductiveness of the fragment and the unusual. He sought out Jean Renoir in an attempt to expand an impressionistic poetics of the snapshot through filmmaking. The pages Renoir devotes to *Toni* in his autobiography surpass the text of *The Decisive Moment* in defining the ambition of an art of composition in tune with the times. Shot in 1934 (from a screenplay co-authored by Carl Einstein), *Toni* marked a turning point in Renoir's films, before *La*

17 Evans was to declare in 1971, 'I think what I am doing is valid and worth doing, and I use the word *transcendent.*' In the same interview, he compares Atget, 'who was a kind of medium', to William Blake. Leslie Katz, 'An Interview with Walker Evans', *Art in America*, March-April 1971, reprinted in Vicki Goldberg (ed.), *Photography in Print* (New York: Simon and Schuster, 1981), pp. 365, 366. Evans applies the same term to Cartier-Bresson in his commentary in *Quality*: 'Cartier has always been a kind of spirit medium: poetry sometimes speaks through his camera.'

Grande Illusion. He wanted, he says, to avoid 'fragmentation' and sought a form which allowed him to break 'the isolation of the individual'. In this film, he indicates, 'I realized the importance of unity . . .' and turned to the use of panning shots as a means of clearly linking the characters to each other and their surroundings.[18] The means of photography are clearly more limited than those of film, and this is why Cartier-Bresson, like so many other photographers, tried his hand at filmmaking. But the fact that he chose to work with Renoir in 1936, after studying with Paul Strand in New York, is significant. The idea of *composition*, which he constantly stressed, belongs to the vocabulary of the fine arts and has practically no meaning, or one which is terribly reduced, in the language of the media. Cartier-Bresson thought he could adapt to the demands of *Life*. In reproaching him for his big, beautiful pictures from the four corners of the world, Robert Frank was, in his own way, filling in Evans's silence about the second part of *The Decisive Moment*.[19] But Renoir was speaking of something else. His ambition, as he formulated it with hindsight, was related to a 'unanimist' aim (as poet Jules Romains defined it in his 1908 collection *La vie unanime*).[20] What he did in Martigues – with *Toni* – in the south of France, in 1934, he could not do in the United States, and he went to shoot *The River* (1951) in India. That evolution explains Cartier-Bresson's.

The failure of the 1947 book project was due in part to the fact that it had been (badly) arranged in advance: publisher, writer and designer were all chosen before a single image had been shot. In the course of his travels, Cartier-Bresson was also supposed to produce portraits of writers and artists for *Harper's Bazaar*. To my knowledge, not one of the great photography books of the twentieth century was produced this way, like a film. But this failure took on another significance ten years later, when Robert Frank published *Les Américains/The Americans*.[21] Kerouac's introduction might not be equal to the photos (although it is preferable to that of the original French edition). But the book existed before the text and it constitutes the real extension of the one published by Evans in 1938, even if we should not try to match them up point by point. Between Evans and Frank, the Cartier-Bresson step is missing. We

18 *Jean Renoir, My Life and My Films,* trans. Norman Denny (New York: Atheneum, 1974), pp. 153–155. / 19 'That may be too harsh, but I've always thought it was terribly important to have a point of view, and I was always sort of disappointed in him that that was never in his pictures. He traveled all over the goddamned world, and you never felt that he was moved by something that was happening other than the beauty of it, or just the composition. That's certainly why *Life* gave him big assignments. They knew he wouldn't come up with something that wasn't acceptable.' Interview with Robert Frank in Eugenia Parry Janis and Wendy MacNeil (eds), *Photography Within the Humanities* (Danbury, N. H.: Addison House Publishers, 1977), p. 56. / 20 French poet and writer Jules Romains, born Louis Henri Jean Farigoule (1885–1972), advocated a universal, or 'unanimist' literature which would express the collective consciousness, in opposition to the prevailing exaltation of the individual (translator's note). / 21 For want of an American publisher, Frank's book was first published in French, as *Les Américains* (Paris: R. Delpire, 1958). The original English version appeared the following year as *The Americans* (New York: Grove Press, 1959) (translator's note).

will never know what this book should have been. We can imagine it with the qualities of irony and detachment which Evans was glad to find in Frank's book, which he saw through the filter of his own vision, as an antidote to the sentimental rhetoric of *The Family of Man* (Steichen's exhibition) and the popular press.[22] *The Americans* is a dark, satirical, subjective book; the overall tone is one of stylized pathos, centred on the emotions of a foreign traveller. In his final choice, Frank privileged intensity and an opaque fluidity, like that of the 'heavy water' – stirred up by inner turmoil – described by Gaston Bachelard in *L'Eau et les rêves* (Water and Dreams, 1942). Cartier-Bresson's gaze is clearer but both of them have abandoned any reinterpretation of Evans's settings, concentrating instead on the bodies and faces. Frank's pictures often give the impression that he has just pushed a door open, while Evans shows doorways and facades (or, in *Many Are Called*, faces) and Cartier-Bresson was somewhere in between.

Evans had rejected the pastoral myth and the frontier epic. This stance had the immediate effect of bringing into broad daylight a territory which had previously been kept in the shadow of the news item, in spite of the efforts of a few writers like Hemingway to interpret it. Evans had profited from the Depression to forget Stieglitz's modernist fervour and the New York skyline (the 'vertical' city Europeans dreamed of). Cartier-Bresson and Frank travelled up and down that flat geography devoid of a coastal horizon, eliminating the seeming monotony and ornamental fantasy of the architectural views occupying the second part of *American Photographs*.[23] Evans was obsessed by the necessity of breaking with the standards of an information subjected to what was not yet called the 'visual'; he gave himself a model, an anthropological hypothesis to interrupt the service of current events, free himself – as much as possible – from the illustration of programmed news. This is explicitly indicated in a note reproduced by the editors of *Harper's Bazaar* when they published a few pages of subway portraits in March 1962.[24] It is worth going back to this publication, moreover, in order to understand how Evans's art could burn a hole in the pages of a magazine which was hardly the worst of its kind. Cartier-Bresson, like Frank, was neither able nor

22 Introducing a selection of Frank's photos in 1958, Evans wrote: 'He shows high irony towards a nation that generally speaking has it not; adult detachment towards a more-or-less juvenile section of the population that came into his view. This bracing, almost stinging manner is seldom seen in a sustained collection of photographs. It is a far cry from all the woolly, successful "photo-sentiments" about human familyhood; from the mindless pictorial salestalk around fashionable, guilty and therefore bogus heartfeeling.' *U.S. Camera Annual 1958*, p. 90. / 23 The absence of a coastal horizon in *American Photographs* is one of the specific features of the territory Evans constructed from his exploration of the rural world and the small towns of Middle America. This geographical choice broke with the aesthetic of the sublime tied either to the open, mountainous spaces of the wilderness or to the vertical architecture of the major urban centres of the East Coast (New York par excellence), connected to Europe by the ocean. / 24 'Mr Evans writes of "The Unposed Portrait" on pages 120–125, "The New York subway pictures are a fling in native American contemporary anthropology. With something of the anthropologist's approach, I tried to survey and record the New York subway inhabitants as though I were examining another period and another civilization." 'The Editor's Guest Book', *Harper's Bazaar*, March 1962, p. 107.

willing to make that anthropological hypothesis his own, because the strangeness of the country was already a given for the two European photographers. Cartier-Bresson did his best to forget his reflexes as a 'cosmopolitan foreigner', as his travelling companion from 1947, John Malcolm Brinnin, called him, with a trace of nastiness (or envy).[25] Frank's images cart along with them a jumble of corrupt or absurd symbols, which are substituted for Evans's allegorical motifs. In the case of Cartier-Bresson, satire is rather a way of seeing which is expressed in coincidences or sight gags, but which also allows him to re-discover historical legend. The portrait of the elderly Cape Cod patriot with the American flag draped around her neck for Independence Day is exceptional in the way it evokes speech through gesture (p. 175). Cartier-Bresson recognized the 'robustness' of the pioneers in this figure, something which is unthinkable in Frank's world.

In 1947, Cartier-Bresson had good reasons, which he never disclosed (he contented himself with citing Capa's friendly advice), for preferring the professionalism of reportage to the dilettantism of the miracle. His vision of the world was tolerant, geopolitical and not strictly sentimental or opportunistic, as is too often the case with photojournalists. After his direct experience of the vitality of urban culture in the United States (and in neighbouring Mexico) during the 1930s, he understood that the Second World War had put an end to the political and cultural supremacy of Europe, that the age of empires was over. He wanted to see what that meant, what could be expected of countries which were not (or not yet) associated with the United States and, as in the case of Gandhi's India, subscribed to the liberal democratic model with reticence. His tour of America with Brinnin was above all a farewell to the 1930s, and an opportunity to visit a few friends from the European diaspora, mainly French, refugees (or immigrants), such as Jean Renoir, Max Ernst and Darius Milhaud – a portrait gallery which the *Harper's Bazaar* commission permitted him to fill out with William Faulkner, Henry Miller, Frank Lloyd Wright and others. The contrast with Frank is striking. When he arrived in the United States that same year, 1947 (March), Frank met the art director at *Harper's Bazaar*, Alexey Brodovitch, who gave him work: the circle Cartier-Bresson was moving in was the best, if not the only possibility, for an ambitious European photographer

25 John Malcolm Brinnin, *Sextet: T. S. Eliot & Truman Capote & Others* (New York: Delacorte Press/Seymour Lawrence), 1981, p. 110.

seeking a career in the United States. But after his encounter with Evans, Frank changed his approach. With a Guggenheim Fellowship in hand, he set out on a long, solitary journey throughout the country which had nothing to do with Cartier-Bresson's circular itinerary.

The fact that Frank reinvented the travelogue or recognized the eye of America in the jukebox does not necessarily mark a decisive turning point in the history of twentieth-century art. In France, the Cartier-Bresson/Frank dichotomy, grafted onto the eternal battle between Classicism and Romanticism, attracted a great deal of attention in a photographic culture dominated by the photo essay (*reportage d'auteur*). Cartier-Bresson cannot be accused of adhering to the sentimental consensus of *The Family of Man*. But the fact remains that the resistance to that ideology came rather from Evans's side, in a country where photography had been associated with both national history and modern art debates since the beginning of the century. The encounter between the two photographers was one of the great moments in the shift from the School of Paris to New York. But the gap between them, already visible in 1947, widened in the 1960s, beyond Frank's intervention, when Evans's photos were re-evaluated in the light of Pop and Conceptual art, while Cartier-Bresson was locked, and locked himself, into the world of the photo essay (from which he broke loose in 1966 by leaving Magnum Photos, apart from the distribution of his archives) and was celebrated at the same time in the art world as one of the masters of a phantom-like School of Paris. Making Evans a forerunner of Pop art was an obvious misinterpretation, refuted by the publication of *Many Are Called* and *Message from the Interior* in 1966. But major works have always been misunderstood, deformed, betrayed, on the basis of the contradictory interests of successive generations. In the early 1960s, the revised edition of *Let Us Now Praise Famous Men* and the reprint of *American Photographs* set off another round of interpretations. As Allan Kaprow emphasized, Pop art owed a great deal to the imagery of the 1930s transmitted by Evans.[26] In 1963 Andy Warhol made a silkscreen portrait of the young Robert Rauschenberg surrounded by his family which he entitled *Let Us Now Praise Famous Men (Rauschenberg Family)*. Three years later, Dan Graham, who was the first Conceptual interpreter of Pop art, updated Evans's architectural typology in a photo essay (designed as a magazine piece) entitled

26 See Allan Kaprow, 'Pop Art: Past, Present and Future', *Malabat Review*, July 1967, reprinted in Carol Anne Mahsun (ed.), *Pop Art. The Critical Dialogue* (Ann Arbor, Mich.: UMI Research Press, 1989), p. 63.

Homes for America.[27] All of that made no sense for enthusiasts of the 'decisive moment', much less for Evans's admirers, moreover.[28] But is clear that Cartier-Bresson's work – even limited to the 1930s – did not generate a variety of interpretations in France comparable to those of Evans in the United States.

In his own, inimitable way, Cartier-Bresson waltzed in Evans's footsteps for several weeks in 1947. The comparison is unavoidable. It reflects a new historical examination, free of hagiography. Those few weeks spent crossing the United States (East–West and back again) came just before a turning point in Cartier-Bresson's professional life; they also mark the limits of the dialogue with Evans. On this terrain, inventiveness and experience were on the side of the author of *American Photographs*. It is difficult to imagine how a book could stand apart from it without defining a new approach, as Robert Frank did under totally different circumstances. After Americans in Paris like Man Ray, Cartier-Bresson helped to graft Surrealism onto the New York scene. His photos were seen and appreciated in a circle which was ready to assimilate the idea of a 'poetic document'. In *Changing New York* (1935–39), Berenice Abbott transposed Atget's description of Old Paris. But the America of Evans was not Surrealist; a new demand for realism had emerged with the onset of the Depression in 1929. Right up to Pop art, American art in the post-war period defined itself according to the canons and myths of the 1930s. Cartier-Bresson had another, more universal conception of realism. As shown by the second part of *The Decisive Moment*, devoted to Asia, he was ultimately little concerned with the debates over American culture. And we can also imagine that he had recognized the limits of satire when the myth of abundance was capable of absorbing all the counter-examples which could be provided.

Jean-François Chevrier

27 The piece had been conceived for a generalist magazine like *Esquire*, but ultimately appeared in *Arts Magazine* in a truncated version, without Graham's photographs and illustrated solely by the Walker Evans photo reproduced on the cover of the 1962 reprint of *American Photographs*. / 28 Until the beginning of the 1990s – as I know from experience – the Walker Evans/Dan Graham connection, for example, remained a scandal for the temple guardians: the master of the 'documentary style' in so-called 'modernist' (straight) photography and the anti-modernist 'conceptual' artist could not be associated without causing harm to one or the other.

PLATES

Walker Evans *New York, 1929*

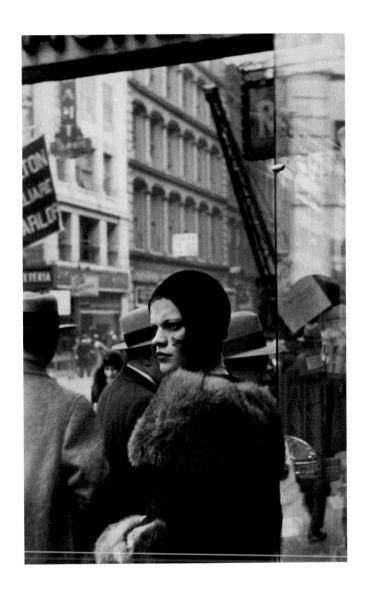

Walker Evans *New York, 1931*

Walker Evans *Coney Island, c. 1929*

Walker Evans *Small Town, 1932*

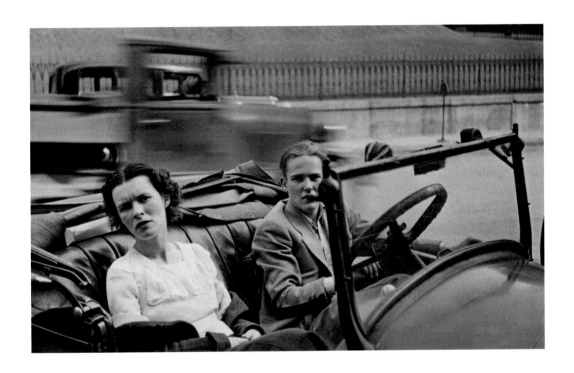

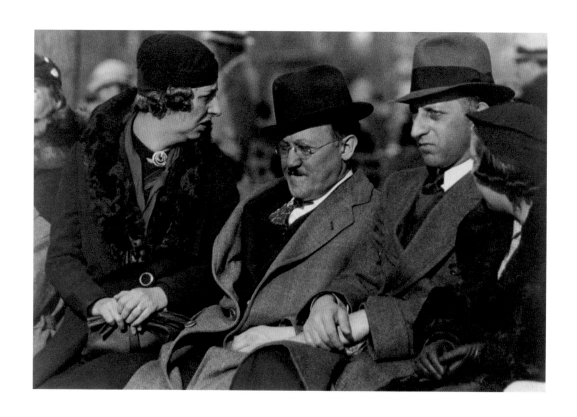

Walker Evans *Bronx, 1933*

Walker Evans *Coney Island, 1929*

Walker Evans *Saratoga Springs, New York, 1931*

Walker Evans *New York, 1931*

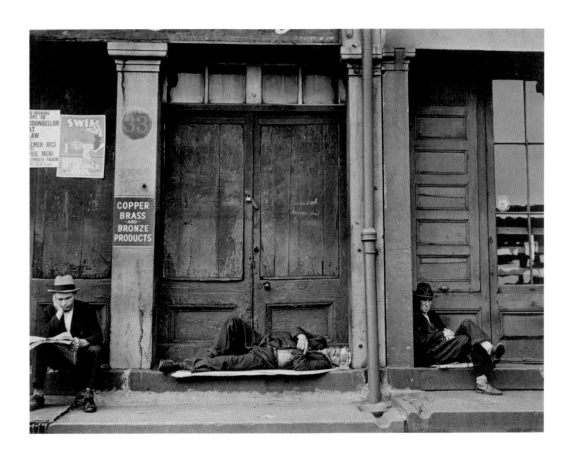

Walker Evans *New York, 1932*

Walker Evans *New York, 1932*

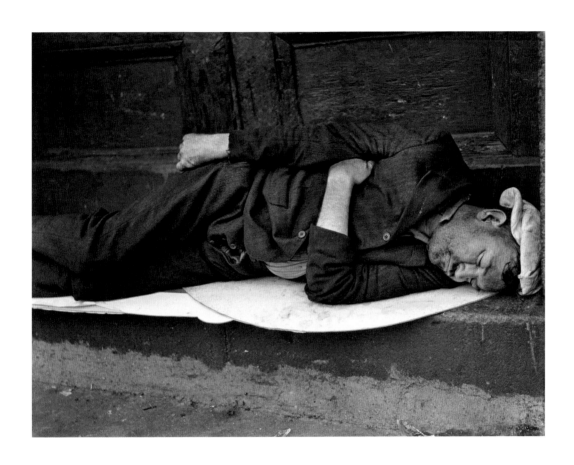

Walker Evans *New York, 1930*

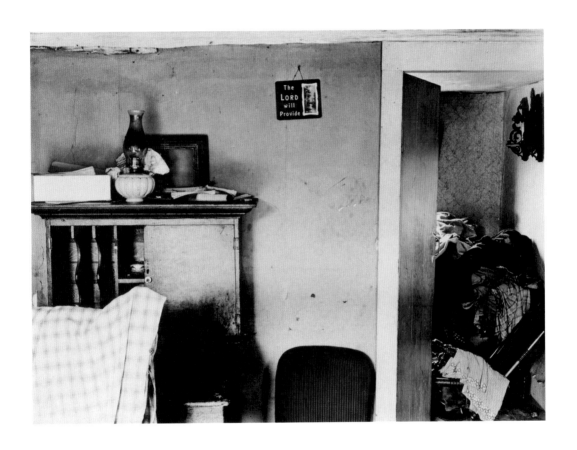

Walker Evans *New York, 1931*

Walker Evans *New York, 1929*

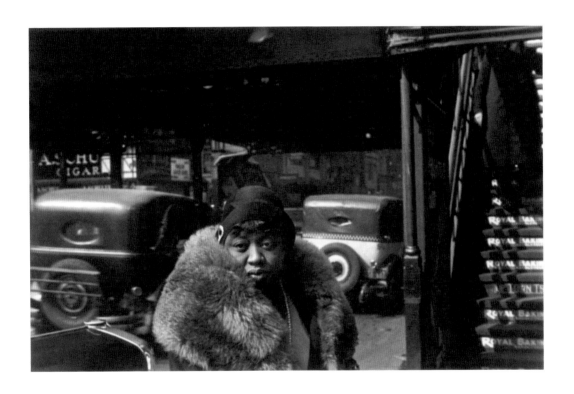

Walker Evans *New York, 1934*

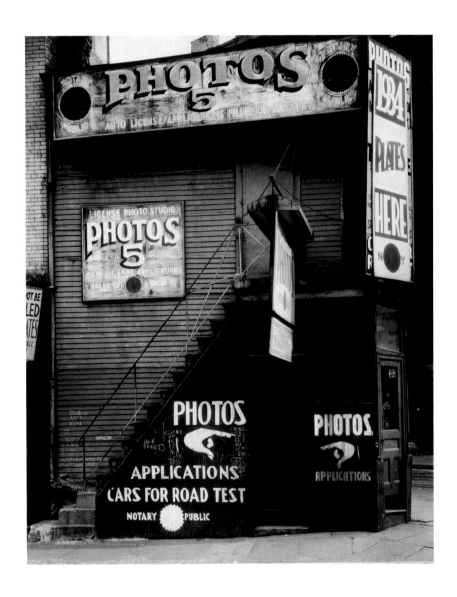

Henri Cartier-Bresson *Manhattan, 1946*

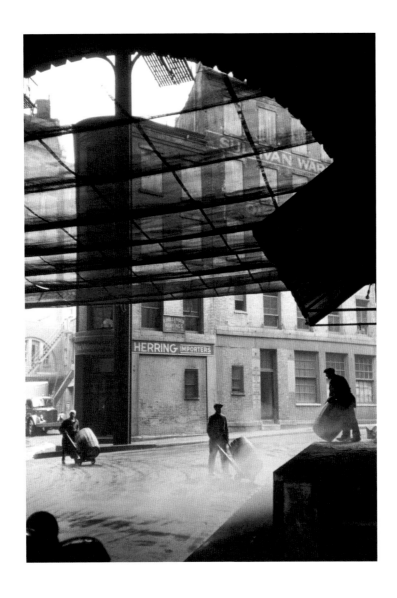

Henri Cartier-Bresson *Brooklyn, 1946*

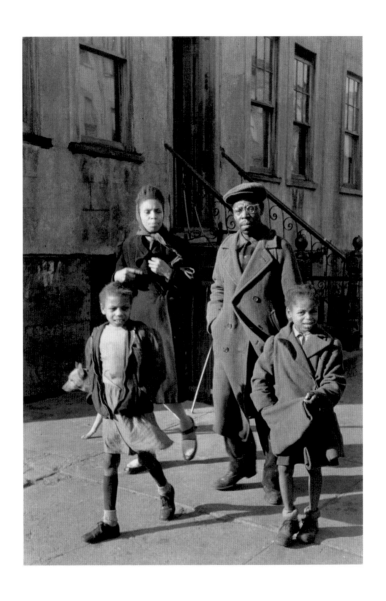

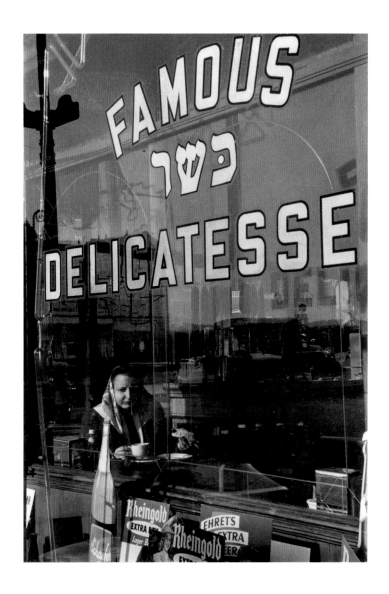

Henri Cartier-Bresson *Brooklyn, 1947*

Henri Cartier-Bresson *Queens, 1947*

Henri Cartier-Bresson *Manhattan, 1947*

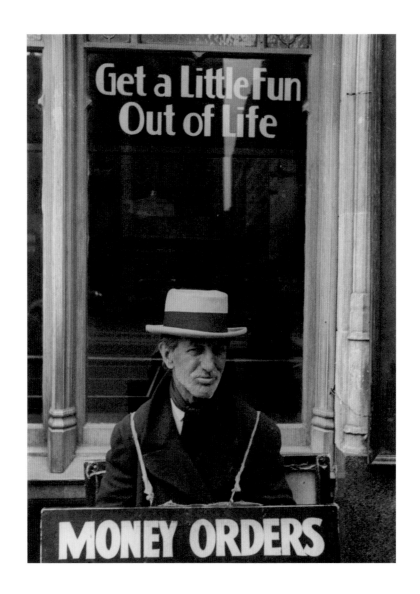

Henri Cartier-Bresson *Manhattan, 1946*

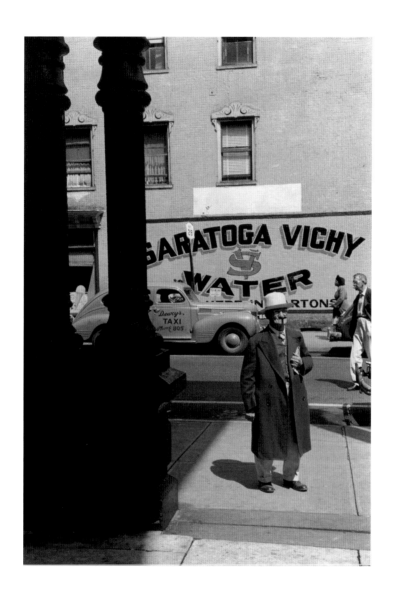

Henri Cartier-Bresson *Saratoga, New York, 1946*

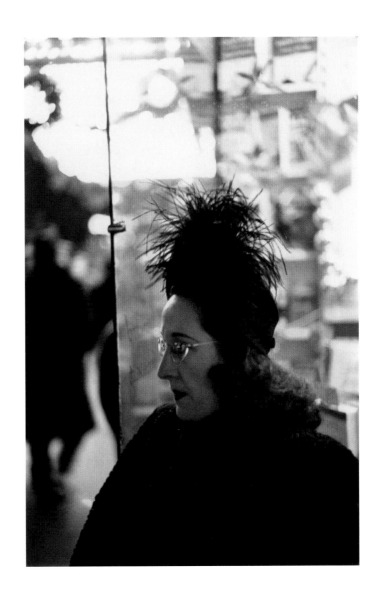

Henri Cartier-Bresson *Manhattan, 1947*

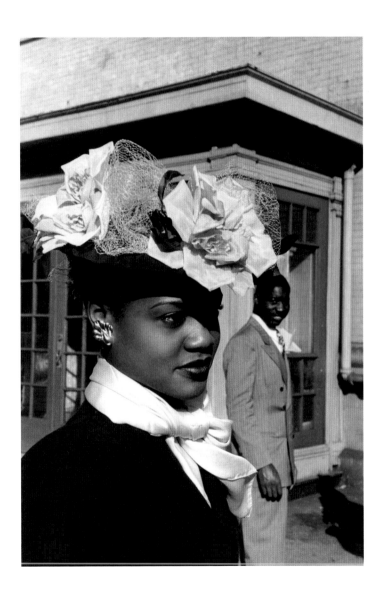

Henri Cartier-Bresson *Harlem, 1947*

Henri Cartier-Bresson *Brooklyn, 1947*

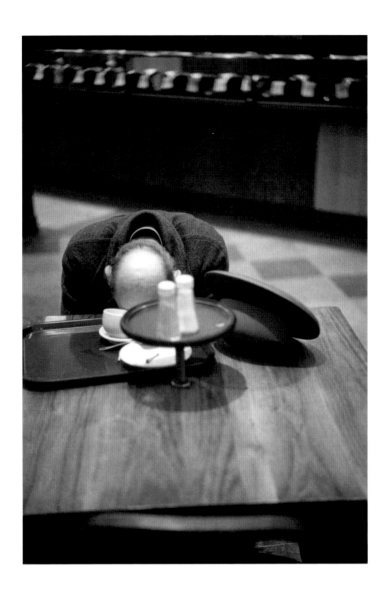

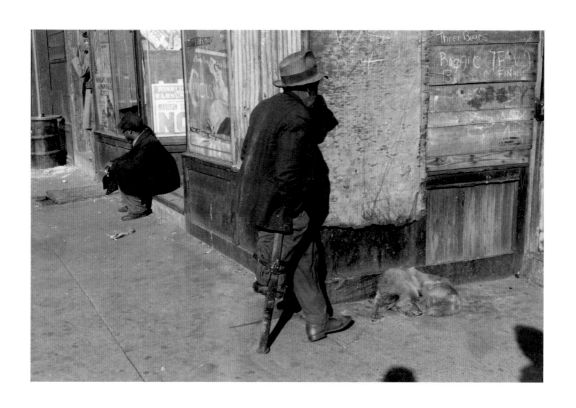

Henri Cartier-Bresson *Brooklyn, 1947*

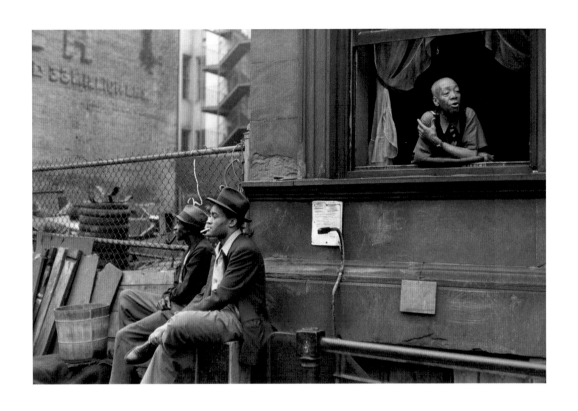

Henri Cartier-Bresson *Harlem, 1947*

Henri Cartier-Bresson *Manhattan, 1947*

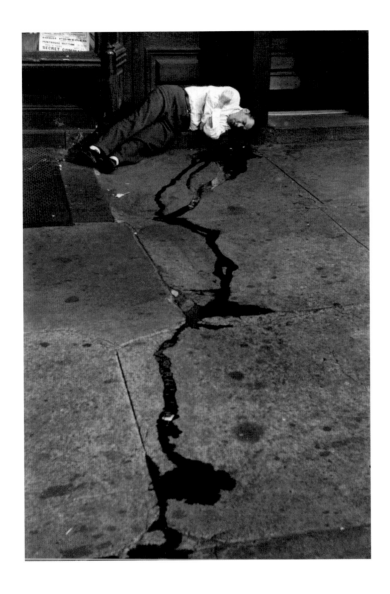

Walker Evans *Birmingham, Alabama, 1936*

Walker Evans *Greensboro, Alabama, 1936*

Walker Evans *Alabama, 1935*

Walker Evans *Savannah, Georgia, 1936*

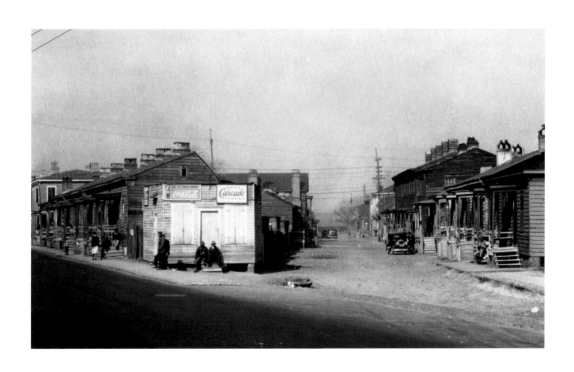

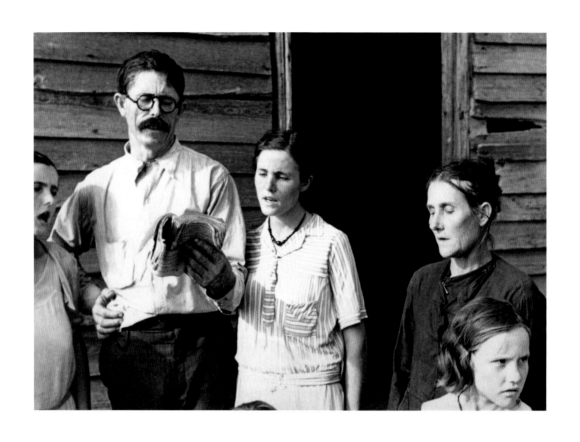

Walker Evans *Alabama, 1936*

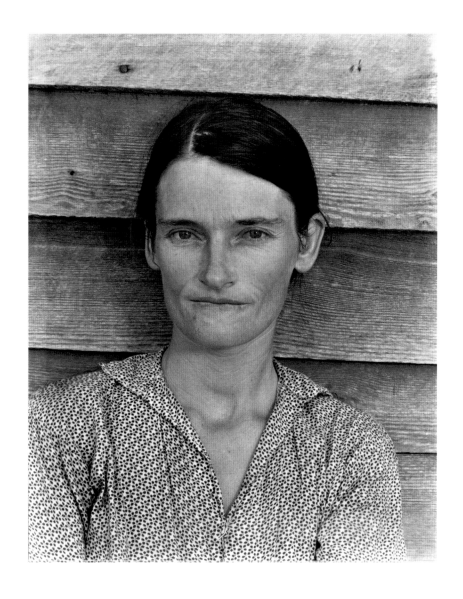

Walker Evans *Alabama, 1936*

Walker Evans *Alabama, 1936*

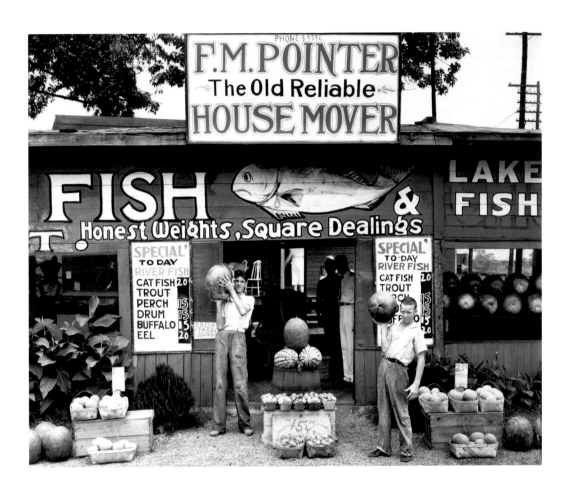

Walker Evans *Alabama, 1936*

Walker Evans *Birmingham, Alabama, 1936*

Henri Cartier-Bresson *Memphis, Tennessee, 1947*

Henri Cartier-Bresson *Memphis, Tennessee, 1947*

Henri Cartier-Bresson *Knoxville, Tennessee, 1947*

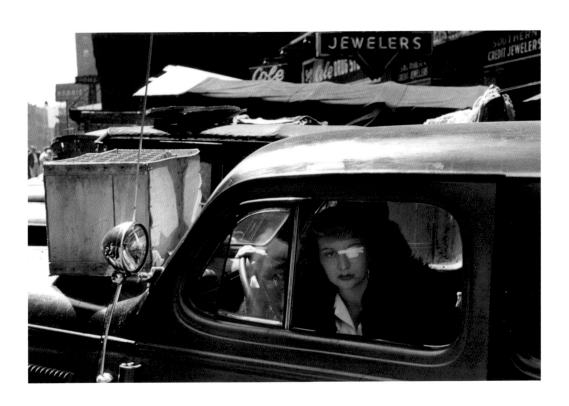

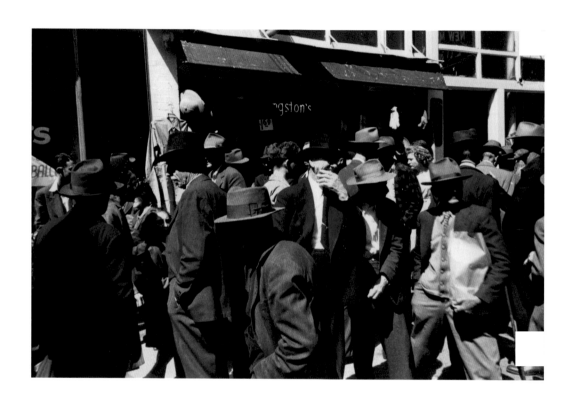

Henri Cartier-Bresson *Knoxville, Tennessee, 1947*

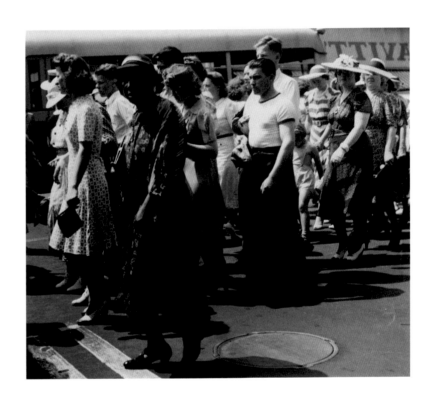

Walker Evans *Bridgeport, Connecticut, 1941*

Walker Evans *Bethlehem, Pennsylvania, 1935*

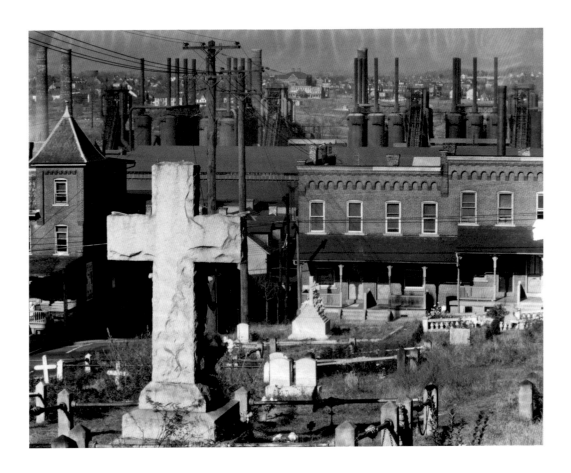

Walker Evans *Pennsylvania, 1935*

Walker Evans *Pennsylvania, 1935*

Walker Evans *American Legionnaire, 1935*

Walker Evans *Bethlehem, Pennsylvania, 1935*

Walker Evans *Massachusetts, circa 1930*

Walker Evans *Florida, circa 1930*

Walker Evans *Westchester, New York, 1931*

Henri Cartier-Bresson *Arizona, 1947*

Henri Cartier-Bresson *Jackson, Mississippi, 1947*

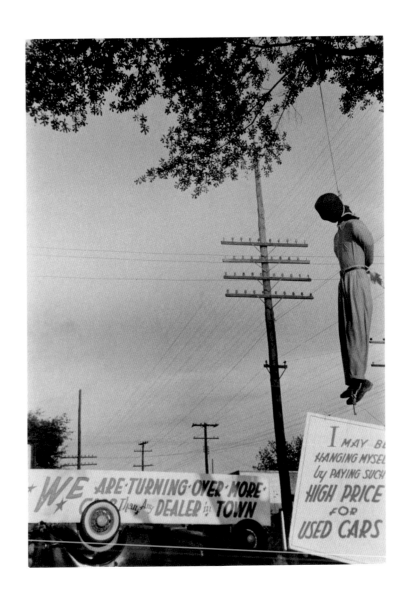

Walker Evans *Mississippi, 1948*

Henri Cartier-Bresson *Vicksburg, Mississippi, 1947*

Henri Cartier-Bresson *Natchez, Mississippi, 1947*

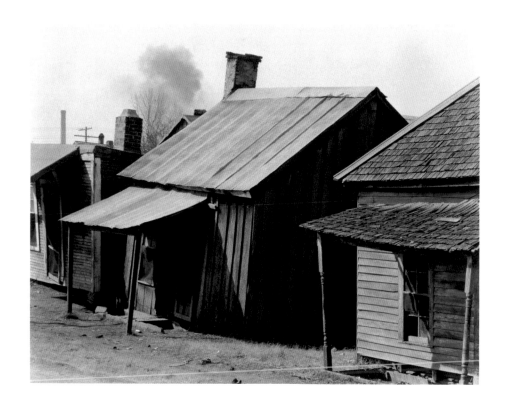

Walker Evans *Tupelo, Mississippi, 1936*

Walker Evans *Vicksburg, Mississippi, 1936*

Walker Evans *Vicksburg, Mississippi, 1936*

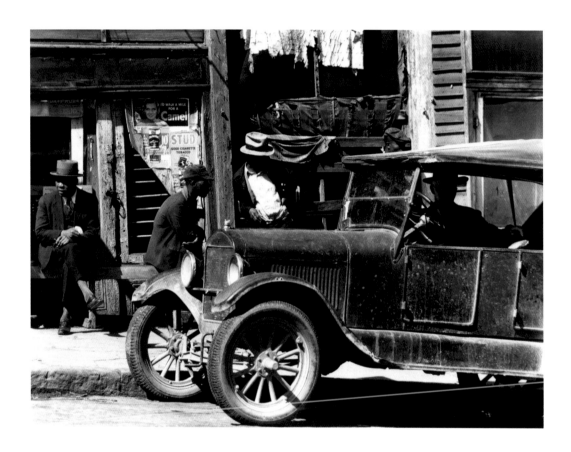

Walker Evans *New Orleans, 1935*

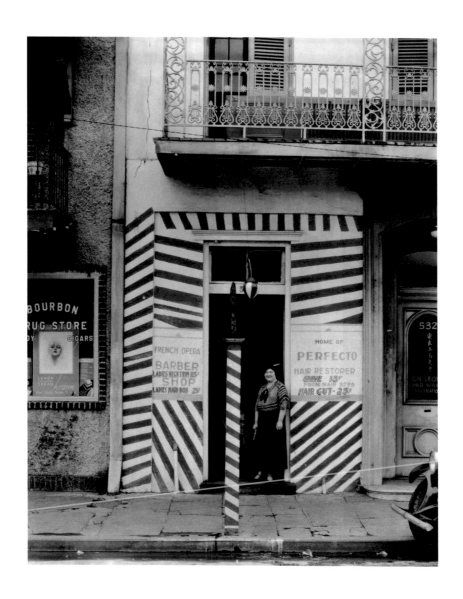

Henri Cartier-Bresson *New Orleans, 1947*

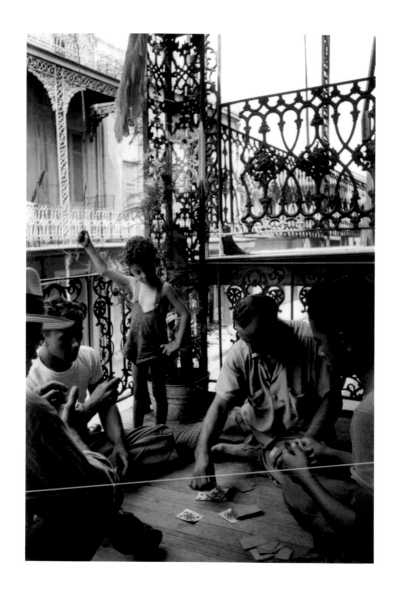

Henri Cartier-Bresson *New Orleans, 1947*

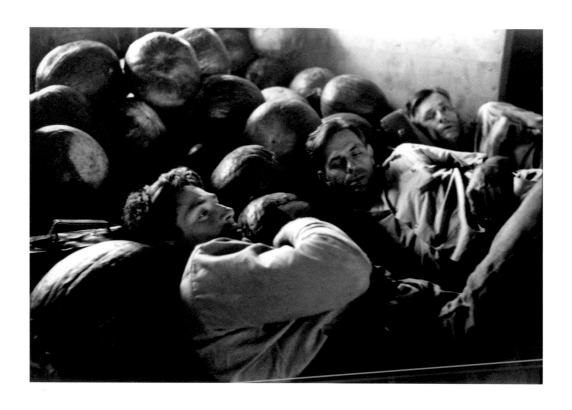

Henri Cartier-Bresson *New Orleans, 1947*

Henri Cartier-Bresson *New Orleans, 1947*

Henri Cartier-Bresson *New Orleans, 1947*

Henri Cartier-Bresson *New Orleans, 1947*

Henri Cartier-Bresson *New Orleans, 1947*

Henri Cartier-Bresson *New Orleans, 1947*

Henri Cartier-Bresson *Taos, New Mexico, 1947*

Henri Cartier-Bresson *San Antonio, Texas, 1947*

149

Henri Cartier-Bresson *Iowa, 1947*

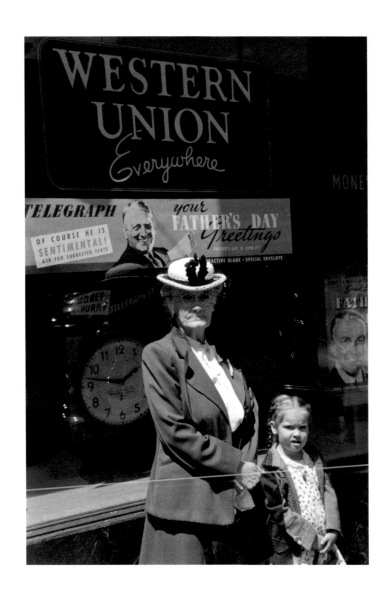

Walker Evans *Morgantown, West Virginia, 1935*

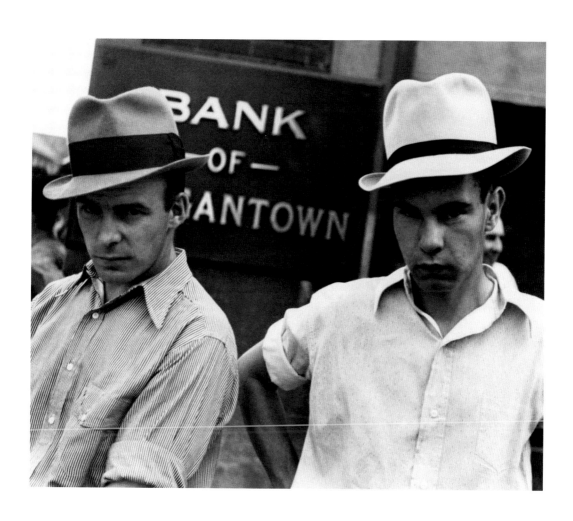

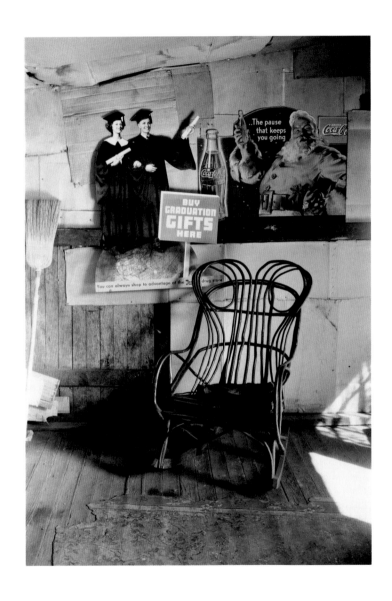

Walker Evans *West Virginia, 1935*

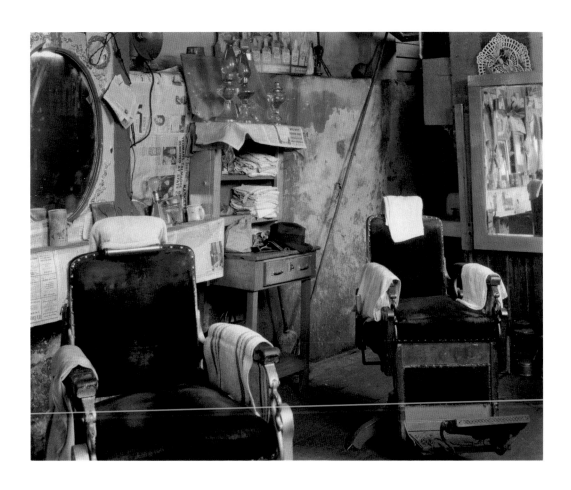

Walker Evans *Atlanta, 1936*

Walker Evans *Arkansas, 1937*

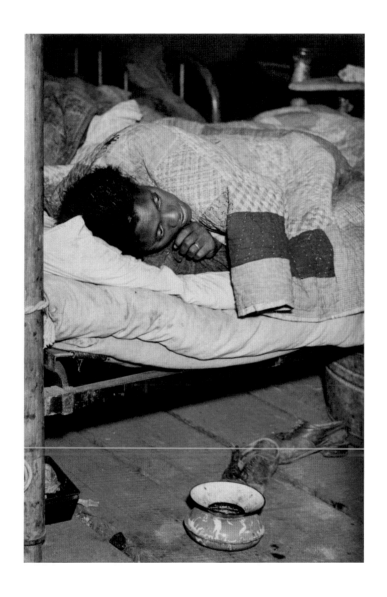

Henri Cartier-Bresson *Washington, 1947*

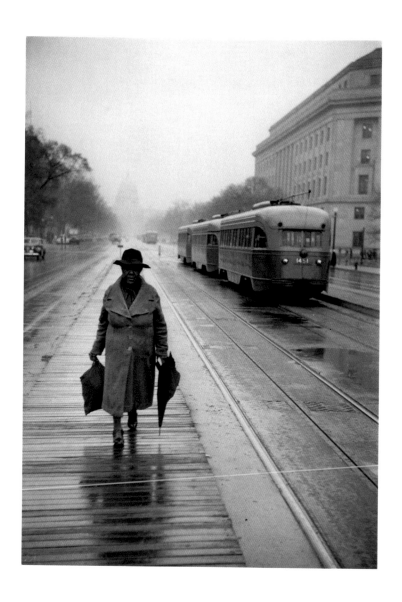

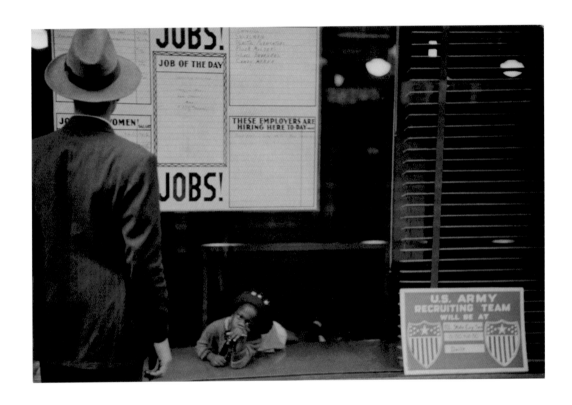

Henri Cartier-Bresson *Chicago, Illinois, 1947*

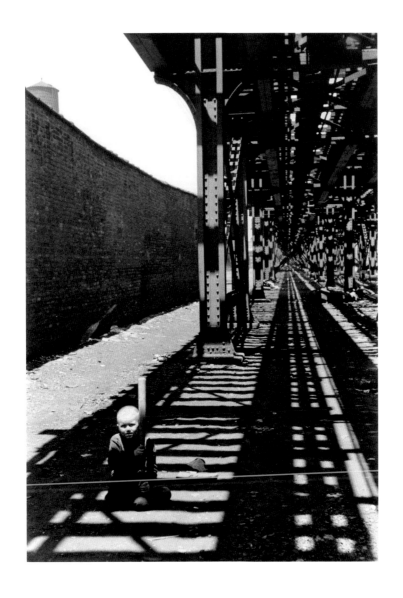

Henri Cartier-Bresson *Chicago, Illinois, 1947*

Henri Cartier-Bresson *Chicago, Illinois, 1947*

Henri Cartier-Bresson *Chicago, Illinois, 1947*

Henri Cartier-Bresson *Chicago, Illinois, 1946*

Henri Cartier-Bresson *Los Angeles, 1946*

Henri Cartier-Bresson *Washington, 1947*

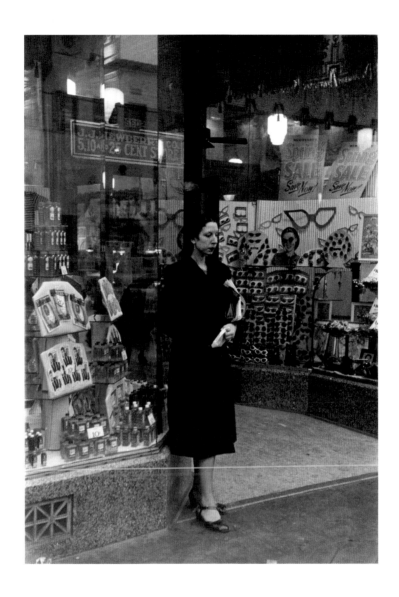

Henri Cartier-Bresson *Chinatown, San Francisco, 1946*

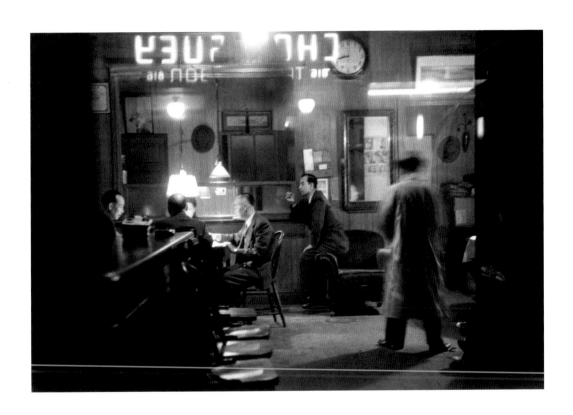

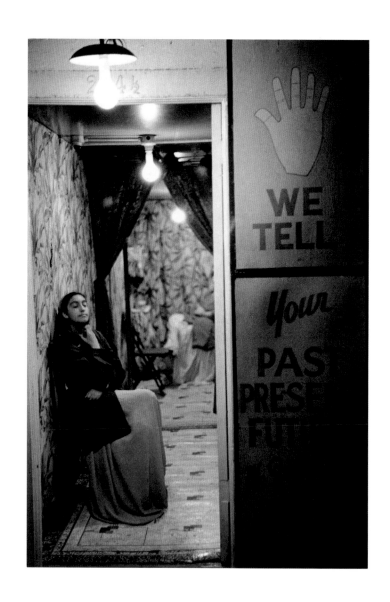

Henri Cartier-Bresson *Reno, Nevada, 1947*

Walker Evans *Southern States, circa 1936*

Walker Evans *Massachusetts Village, 1929*

Henri Cartier-Bresson *Cape Cod, Massachusetts, 1947*

*All photographs by Henri Cartier-Bresson belong to
the collection of Fondation HCB, Paris.*

Page 51
Walker Evans
Girl in Fulton Street, New York, 1929
Vintage gelatin silver print
19.1 x 11.7 cm
Collection MoMA, New York

Page 52
Walker Evans
Posed Portraits, New York, 1931
Vintage gelatin silver print
17.7 x 13.9 cm
Collection MoMA, New York

Page 53
Walker Evans
Couple at Coney Island, c. 1929
Vintage gelatin silver print
18.6 x 15.4 cm
Collection J. Paul Getty Museum

Page 55
Walker Evans
*Parked Car, Small Town Main Street,
1932*
Vintage gelatin silver print
14 x 22.7 cm
Collection MoMA, New York

Page 56
Walker Evans
A Bench in the Bronx on Sunday, 1933
Vintage gelatin silver print
13.3 x 19.5 cm
Collection J. Paul Getty Museum

Page 57
Walker Evans
Coney Island Boardwalk, 1929
Vintage gelatin silver print
21.4 x 14.4 cm
Collection J. Paul Getty Museum

Page 59
Walker Evans
Saratoga Springs, New York, 1931
Gelatin silver print, printed later
54.2 x 43 cm
Collection Galerie Baudoin Lebon

Page 60
Walker Evans
*Hudson Street Boardinghouse Detail,
New York, 1931*
Vintage gelatin silver print
14.3 x 18.3 cm
Collection J. Paul Getty Museum

Page 61
Walker Evans
South Street, New York, 1932
Vintage gelatin silver print
14.2 x 16.1 cm
Collection J. Paul Getty Museum

Page 63
Walker Evans
South Street, New York, 1932
Vintage gelatin silver print
15.6 x 20.5 cm
Collection J. Paul Getty Museum

Page 64
Walker Evans
*People in Summer, New York State Town,
1930*
Vintage gelatin silver print
23.5 x 16.7 cm
Collection MoMA, New York

Page 65
Walker Evans
New York State Farm Interior, 1931
Vintage gelatin silver print
18.3 x 22.4 cm
Collection J. Paul Getty Museum

Page 67
Walker Evans
6th Avenue, New York, 1929
Vintage gelatin silver print
12.1 x 18.6 cm
Collection J. Paul Getty Museum

Page 69
Walker Evans
License Photo Studio, New York, 1934
Vintage gelatin silver print
18.3 x 14.4 cm
Collection J. Paul Getty Museum

Page 71
Henri Cartier-Bresson
*Fulton Street, Manhattan, New York,
1946*
Gelatin silver print, 2007
26.2 x 17.7 cm
HCB1946048W00013/06A//1

Page 73
Henri Cartier-Bresson
Negro Quarter, Brooklyn, New York, 1946
Vintage gelatin silver print
24.6 x 16.4 cm
HCB1946053W00058/24//1

Page 74
Henri Cartier-Bresson
Jewish Quarter, Brooklyn, New York, 1947
Vintage gelatin silver print
24.9 x 16.8 cm
HCB1946053W00057/02//1

Page 75
Henri Cartier-Bresson
Queens, New York, 1947
Modern gelatin silver print
27.5 x 18.3 cm
HCB1946053W00055/42

Vintage gelatin silver print
18.4 x 22.9 cm
Collection J. Paul Getty Museum

Page 101
Henri Cartier-Bresson
Memphis, Tennessee, 1947
Vintage gelatin silver print
24.7 x 16.8 cm
HCB1946005W00005/34//1

Page 103
Henri Cartier-Bresson
Memphis, Tennessee, 1947
Vintage gelatin silver print
25.2 x 17.3 cm
HCB1946006W00006/34//1

Page 105
Henri Cartier-Bresson
Knoxville, Tennessee, 1947
Gelatin silver print, printed in the 1970s
15.9 x 23.9 cm
HCB1946005W00001/09C//4

Page 106
Henri Cartier-Bresson
Knoxville, Tennessee, 1947
Gelatin silver print, printed in the 1970s
20 x 29.9 cm
HCB1946005W00001/01//1

Page 107
Walker Evans
In Bridgeport's war factories, 1941
Vintage gelatin silver print
20 x 25 cm
Collection Sandra Alvarez de Toledo

Page 109
Walker Evans
Graveyard, Houses and Steel Mill,

Bethlehem, Pennsylvania, 1935
Vintage gelatin silver print
19.2 x 24.2 cm
Collection J. Paul Getty Museum

Page 111
Walker Evans
'Joe's Auto Graveyard', Pennsylvania,
1935
Vintage gelatin silver print
10.3 x 14.4 cm
Collection J. Paul Getty Museum

Page 113
Walker Evans
World War I Monument on Main St.,
Pennsylvania, 1935
Vintage gelatin silver print
20.4 x 17.8 cm
Collection J. Paul Getty Museum

Page 114
Walker Evans
American Legionnaire, 1935
Vintage gelatin silver print
15.1 x 22.3 cm
Collection J. Paul Getty Museum

Page 115
Walker Evans
Sons of the American Legion, Bethlehem,
Pennsylvania, 1935
Vintage gelatin silver print
16.7 x 18.3 cm
Collection J. Paul Getty Museum

Page 116
Walker Evans
The Cactus Plant, Interior Detail of a
Portuguese House, Truro, Massachusetts,
circa 1930
Vintage gelatin silver print

19.8 x 15.1 cm
Collection J. Paul Getty Museum

Page 117
Walker Evans
Interior with Mirror and Framed
Mementos, Florida, circa 1930
Vintage gelatin silver print
20.6 x 15.7 cm
Collection J. Paul Getty Museum

Page 119
Walker Evans
Farmhouse, Westchester, New York,
1931
Vintage gelatin silver print
18 x 22.1 cm
Collection Centre Georges Pompidou,
MNAM / CCI

Page 121
Henri Cartier-Bresson
Arizona, 1947
Gelatin silver print, printed in
the 1970s
19.9 x 29.6 cm
HCB1946013W00001/04C//7

Page 123
Henri Cartier-Bresson
Jackson, Mississippi, 1947
Vintage gelatin silver print
24.4 x 17 cm
HCB1946006W00003/21//1

Page 124
Walker Evans
Faulkner's Mississippi, c. 1947
Vintage gelatin silver print
25.5 x 20 cm
Collection Galerie Baudoin Lebon

Vintage gelatin silver print
14.2 x 16.8 cm
Collection MoMA, New York

Page 154
Walker Evans
Interior Detail, Coal Miner's House,
West Virginia, 1935
Vintage gelatin silver print
23.7 x 16 cm
Collection J. Paul Getty Museum

Page 155
Walker Evans
Negro Barber Shop Interior, Atlanta, 1936
Vintage gelatin silver print
18.9 x 23.2 cm
Collection MoMA, New York

Page 157
Walker Evans
Arkansas Flood Refugee, 1937
Vintage gelatin silver print
19.5 x 12.9 cm
Collection J. Paul Getty Museum

Page 159
Henri Cartier-Bresson
Washington, 1947
Vintage gelatin silver print
24.4 x 16.8 cm
HCB1946004W00002/30//1

Page 160
Henri Cartier-Bresson
Chicago, Illinois, 1947
Vintage gelatin silver print
17 x 24.8 cm
HCB1946027W00001/06//4

Page 161
Henri Cartier-Bresson
Chicago, Illinois, 1947

Vintage gelatin silver print
24 x 16.4 cm
HCB1946027W00004/24C//1

Page 163
Henri Cartier-Bresson
Chicago, Illinois, 1947
Vintage gelatin silver print
24.6 x 16.8 cm
HCB1946028W00003/10//1

Page 164
Henri Cartier-Bresson
Chicago, Illinois, 1947
Gelatin silver print, printed in the 1970s
24.1 x 16.2 cm
HCB1946027W00004/03//3

Page 165
Henri Cartier-Bresson
Chicago, Illinois, 1947
Gelatin silver print, printed in the 1970s
25 x 16.5 cm
HCB1946026W00005/23//4

Page 167
Henri Cartier-Bresson
Hollywood Boulevard, Los Angeles, 1946
Vintage gelatin silver print
16.9 x 24.7 cm
HCB1946019W00010/05//3

Page 169
Henri Cartier-Bresson
Washington, 1947
Vintage gelatin silver print
24.6 x 17 cm
HCB1946019W00013/36//1

Page 171
Henri Cartier-Bresson
Chinatown, San Francisco, 1946

Vintage gelatin silver print
16.7 x 24.3 cm
HCB1946019W00037/32//1

Page 172
Henri Cartier-Bresson
Reno, 1947
Vintage gelatin silver print
24.3 x 16.2 x 0.3 cm
HCB1946022W00001/28//1

Page 173
Walker Evans
'Madam Adele', Southern United States,
circa 1936
Vintage gelatin silver print
14 x 8.8 cm
Collection J. Paul Getty Museum

Page 174
Walker Evans
Political Poster, Massachusetts Village,
1929
Vintage gelatin silver print
15.6 x 10.6 cm
Collection J. Paul Getty Museum

Page 175
Henri Cartier-Bresson
Fourth of July, Cape Cod, Massachusetts,
1947
Vintage gelatin silver print
24.5 x 17 cm
HCB1946038W00011/38C//7

401325423

The original French-language edition of this book was published on the occasion of the exhibition
'Henri Cartier-Bresson / Walker Evans, Photographing America 1929–1947' at the
Fondation Henri Cartier-Bresson, to mark the centenary of Henri Cartier-Bresson's birth.

Curator: Agnès Sire
Editorial coordination: Pauline Vermare
Registrar: Aude Raimbault
Assistants: Henri Daudet and Jessica Retailleau

Fondation HCB wishes to thank Sandra Alvarez de Toledo, Quentin Bajac, Caroline Bouchard,
Clément Chéroux, Verna Curtis, Sylviane de Decker, Marie-Thérèse Dumas, Mia Fineman, Martine Franck,
Peter Galassi, Karen Hellman, Judith Keller, Baudoin Lebon, Élia Pijollet, Weston Naef, Patrick Remy,
Eva Respini, Jeff Rosenheim and Gerhard Steidl.

FONDATION
H·C·B
Henri Cartier-Bresson

Picture credits

The collection of the J.P. Getty Museum, Los Angeles / The collection of the Museum of Modern Art
(MoMA), New York / The collection of Centre Pompidou, MNAM / CCI, Dist. RMN, Paris /
The collection of Galerie Baudoin Lebon, Paris / The collection of Sandra Alvarez de Toledo, Paris /
The collection of Fondation Henri Cartier-Bresson, Paris

First published in the United Kingdom in 2009 by
Thames & Hudson Ltd, 181A High Holborn,
London WC1V 7QX

www.thamesandhudson.com

First published in 2009 in hardcover in the United States of America by
Thames & Hudson Inc., 500 Fifth Avenue, New York, New York 10110

thamesandhudsonusa.com

Photographs © 2008 Henri Cartier-Bresson / Magnum Photos / Collection Fondation HCB
Photographs from pages 51 to 69, 107, 116 to 119, 133 to 174 © 2008 Walker Evans / The Metropolitan Museum of Art
Text © 2008 the authors
This edition © 2009 Thames & Hudson, London

British Library Cataloguing-in-Publication Data
A catalogue record for this book is available from the British Library

Library of Congress Catalog Card Number 2008908221

ISBN: 978-0-500-54370-2

Printed and bound in Germany